IMAGES
of America

GRASS VALLEY

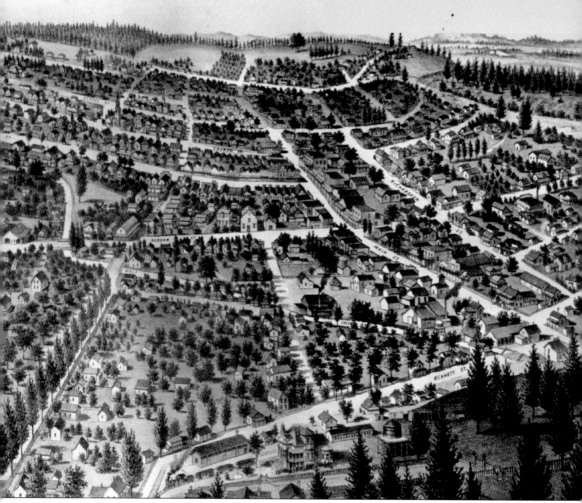

GRASS VALLEY IN 1889. Far from turning into a ghost town like other gold rush settlements, Grass Valley prospered and grew to over 7,000 by 1889. This aerial view looking west shows how the town spread along Main Street, Mill Street, and Wolf Creek all the way from Boston Ravine. Chinatown is visible in the center, between Auburn and Bank Streets and the creek. At bottom right, a steam locomotive is pulling out of the train station next to the Kidder Mansion (see page 72). (City of Grass Valley.)

ON THE COVER: A festive Fourth of July celebration takes place on Grass Valley's Mill Street in 1866. The intersection of the town's two main thoroughfares was planked to prevent dust and mud from hampering traffic and commerce. The horse sign in the center advertised a blacksmith and wagon repair shop, as important then as garages are today. The present-day Grass Valley Hardware building is visible on right (see page 82). (Society of California Pioneers.)

IMAGES
of America

GRASS VALLEY

Claudine Chalmers
Grass Valley Downtown Association

ARCADIA
PUBLISHING

Published by Arcadia Publishing
Charleston SC, Chicago IL, Portsmouth NH, San Francisco CA

Printed in the United States of America

Library of Congress Catalog Card Number: 2006932237

For all general information contact Arcadia Publishing at:
Telephone 843-853-2070
Fax 843-853-0044
E-mail sales@arcadiapublishing.com
For customer service and orders:
Toll-Free 1-888-313-2665

Visit us on the Internet at www.arcadiapublishing.com

This book is dedicated to Ed Tyson, who has tirelessly promoted the cause of history in Nevada County, was instrumental in saving the Nevada City historic district, and has been the heart and soul of the Searls Library for over three decades.

PHOTOGRAPHER AND PRESERVATIONIST. Jim Johnson developed his first roll of film at age 13, and he has studied and worked in the field of photography and graphic reproduction ever since. After developing a special interest in large-scale photographic reproductions, Jim founded Heritage Graphics, which has for 35 years specialized in preserving and restoring thousands of historic images of Northern California and Nevada, turning them into large-scale murals that now decorate businesses in 24 states.

CONTENTS

ACKNOWLEDGMENTS

The challenging task of encapsulating 100 years of Grass Valley history was made much easier thanks to the help I received from many people. Professional photographer Jim Johnson not only provided a treasure trove of photographs from his huge collection of around 10,000 negatives, but his prints have outstanding quality and his practice of enlarging these old images has given him great insights into their telling details. Howard Levine, Judy Roth, and their dynamic Grass Valley Downtown Association were especially helpful for the valuable contacts and excellent information they supplied. I am grateful to Tsi-Akim tribal chairman Don Ryberg for his patient guidance in untangling the myths and the realities of the Maidu's painful past and present legacy. David Comstock was a most valued guide and provided last-minute, must-have images. His Comstock Bonanza Press books and ever-ongoing research represent a formidable primary source of essential information on Nevada County's history. My thanks go to him and to his wife, Ardis. I was inspired by the work of Michel Janicot, with whom I share a great interest in California's French pioneers, and by Robert Wyckoff, whose walks I followed, his book in hand. Charles and Cece Fowler generously contributed their family photographs, as did Midge Scotten, Ed and Alice Yun, Jack Bennett, and Phil Oyung, making the overall picture that much more personal and providing additional readings to make sure I had the facts right. I spent wonderful moments and received both help and encouragement from Margaret Castle and Cece Fowler at the Grass Valley Museum, Paul Scheer at the North Star Mining Museum, Wally Hagaman at the Firehouse No. 1 Museum, and local historical renovator extraordinaire LaVonne Mullin. Their images added yet another piece to this tapestry, as did the rare images provided by Carl Mautz, bottles from Aaron and Shelley Hill's amazing collection, and the information from Jacques Perilhou's superb library in Carcassonne, France. I appreciate the kind help extended to me by the staff at the Madeleine Helling Library, the Searls Library, the Doris Foley Historical Library, and the Nevada County Railroad Museum. Finally, Leonard Berardi, Hannah Clayborn at Arcadia Publishing, and my Sierra Writers group provided their priceless encouragements, expertise, and support.

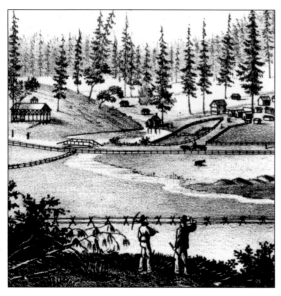

WOLF CREEK, 1852. Grass Valley first appeared as a gold camp on the banks of Wolf Creek. (Leonard Berardi.)

INTRODUCTION

"A fertile valley with tall and juicy grass that billowed before the breeze and waved in noonday sun." That is how Grass Valley first appeared to immigrants, and that was the dominant quality reflected in the town's name. This beautiful, fertile valley was home to hundreds of Maidu who lived on little knolls, ridges, and flats between Wolf Creek and present-day Indian Flat. They knew of the gold in the creeks, but they had no use for it except for an occasional decoration or gift. They were rich from the abundance of food and the beauty of the quiet valley where they and their ancestors before them had lived for thousands of years.

The first whites to cross the valley never suspected or even dreamed of just how much gold rested beneath the fertile soil. There was gold in the creeks, gold in the bedrock, gold in every shape and form—nuggets, dust, and delicate crystals. After Marshall's find at Coloma turned California into the land of glittering dreams, every creek and river came under scrutiny in the ensuing gold rush. "Gold fever was contagious as the itch," a miner wrote. "If you took it, brimstone and grease would not cure you. The only remedy was for you to go to the mines and try your luck." Men from the world over at first trickled in, then rushed in, some all the way to Wolf Creek where they set to work, shoulder to shoulder, feverishly laboring their pans and rockers, lifting boulders, diverting creeks, uprooting trees, digging at times under their own hastily built cabins, and washing down entire hillsides with water cannons.

"My Indians are melting like snow before the march of the civilized white," a southern Maidu chief despaired as this unruly, disparate group of men, half of them foreigners, devastated the quiet valley where generations of Nisenan had lived in peace. For the whites, this was a beginning. For the Maidu, it was the end. They progressively vanished, as did the trees, the peace, and the wildlife, all in the destructive name of the ever-growing gold frenzy.

Chaos redoubled after Grass Valley became the site of California's second great gold rush. Gold was found in a ledge of quartz on Gold Mountain, soon renamed more accurately Gold Hill. Miners turned to hillsides with hammers, digging up the ore, pounding it with hand mortars. They perforated the land with hundreds of "coyote" holes, where they were lowered in buckets. As they were forced to dig deeper and deeper, to use bigger and more powerful machinery, quartz miners' lives became ruled night and day by the eternal clatter of stamp mills and by the towering headframes, while mountains of tailings piled all around.

A total of $440 million in gold was lifted from streambeds, washed down from dry diggings, and crushed from hard quartz in California's Nevada County, $350 million in Grass Valley alone. The fertility of the soil and the booming economy drew entrepreneurs, but it fascinated entertainers as well. This was, of all places in the world, where the divine Lola Montez chose to put down her bags for two quiet years and where young Lotta Crabtree started her dazzling career. It is where Alonzo "Old Block" Delano wrote his famous tales and where Mark Twain lectured, where John Rollin Ridge—known as Yellow Bird—ended his memorable life and philosopher Josiah Royce was born and grew up.

While other gold rush towns declined due to the gradual depletion of gold in creeks and flats, Grass Valley endured and flourished. With the endless flow of the precious mineral came prosperity. Beautiful homes and mansions were built, and the town was one of the first to be lit by gas and then by electricity. Men who loved the challenges of modern technology built trolleys, trains, spectacular bridges, and steam cars, as well as spectacular new mining improvements. Talented architects and builders designed beautiful theaters and civic buildings. No longer just a crossroad,

the town now became a destination.

When the threat of World War II spread and the United States fixed the price of gold, the giant industry slowed to a crawl. Pumps were pulled, mills were silenced, and the town became disconcertingly quiet. Within 10 years, most miners were gone to Bay Area shipyards and factories, to settle in other cities or farms, or to seek other El Dorados. Postwar attempts to revive the hardrock giants failed in the face of a fixed-price gold economy. The industry did not recover.

The gold is still there, concealed in a surreal web of flooded shafts that crisscross for miles, deep under the valley floor and town. The memory of the excitement is far from gone either. Locals still own claims, work mines, and enjoy crevassing or panning in creeks and rivers on weekends. The town remained a hub, forever a city of gold, a city where spectacular finds continue to happen, where yarns continue to be spun, and where opportunities remain endless.

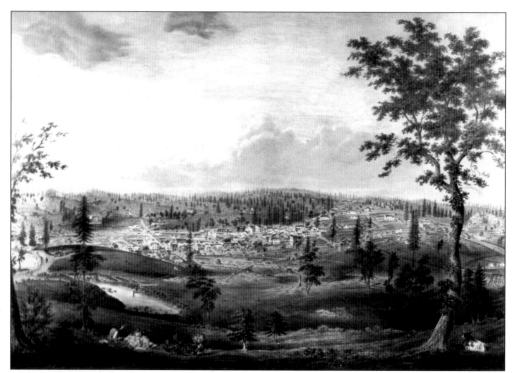

"GRASS THAT BILLOWED BEFORE THE BREEZE." Grass Valley's fertility is such that it always retained garden-like beauty in spite of the upheavals of gold mining, as demonstrated in this 1857 watercolor by Henri Walton. The bucolic touches like the group of Native Americans in the foreground and the cow under the tree are mere artistic devices that define the style of painting much more than they define actual reality. (Society of California Pioneers.)

One

GRASS VALLEY'S MAIDU

California's indigenous Maidu Indian tribe inhabited the Sierra foothills for thousands of years. Their territory stretched from the Cosumnes River to Mount Lassen and from the crest of the Sierras to the Sacramento River. They traveled freely over this huge territory and spoke a common language with local variations. They lived in separate settlements while still referring to themselves as one distinct political unit, a tribelet. Each tribelet usually had one principal village and several allied subsidiary villages.

According to Maidu genealogists, Maidu is a native term that means "man." Based on linguistic evidence, their population was generally divided into three groups: the Nisenan or Southern Maidu, the Mountain or Northeastern Maidu, and the Konkow or Northwestern Maidu. California had about 250 distinct Indian cultures with separate dialects. The Maidu language was placed in the Penutian family.

The southern Maidu or Hill Nisenan (nee-ce-non), meaning "from among us," lived in the foothill Nevada City–Grass Valley area. In the summertime, they traveled up into the high country where there was more water and where they hunted and gathered and lived in small campsites. They kept permanent village sites at lower elevations where winters were mild, valley fog non-existent, and habitation easier in cold weather.

Today's Tsi-Akim (tchai-akim) Maidu tribe has evolved from this once-great nation.

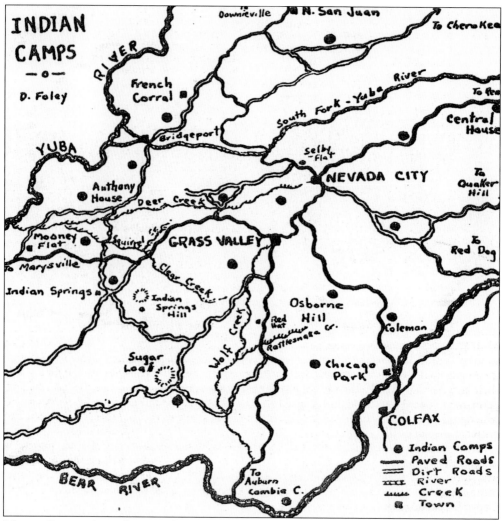

MAIDU CAMPS. According to ethnographers Wilson and Towne, there were five major villages within a six-mile radius of Grass Valley: three large centers with dance houses called *Tuyi* to the southeast; *Tetema*, located northeast of Nevada City; *Kaymapaskan*, located northwest of Grass Valley; and two smaller villages, one called *Hi'et* on Wolf Creek and the other *Tsekankan*, one mile north of Wolf Creek. In 1953, historian Doris Foley created this map of the various locally known Nevada County Maidu camps. Tsi-Akim tribal chairman Don Ryberg points out that one of these camps was renamed *Usto-Ma* or *Ustu* after contact with the whites, not because it meant "out of town," but rather because it incorporated a word they heard all too often: "out," as in "out of here," "get out," the adopted name reflected their new identity as outcasts. Traces of Maidu camps around Grass Valley still exist: pounding holes in granite ledges along Wolf Creek, fishing net weights found in the creek, and arrowheads like those found by local collectors Aaron and Shelley Hill. (Nevada County Historical Society Bulletin, 1953.)

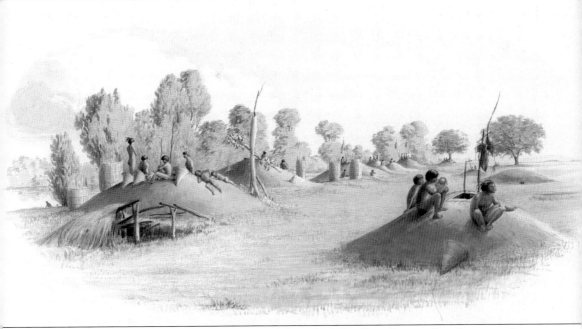

MAIDU LIFE. Maidu villages were generally built on little knolls, ridges, or flats facing southeast so the morning sun would warm the villagers' feet and keep them healthy. From this campsite, the Maidu could see their burial ground and guard it from neighboring tribes who might plunder their ancestors' graves. There was always a spring nearby and easy access to a creek for fishing. Permanent, lower altitude camps consisted of 10 to 12 conical stick frame huts covered with dirt, which made them a perfect shelter, warm and comfortable in winter. The chief's hut stood in the center of the village. The large communal roundhouse was used for ceremony and entertainment. It had an opening at the top, as well as a smoke hole used to beat back the grizzlies that inevitably roamed in search of their food. A certain type of wood that produced acrid, eye-stinging smoke was stored for such emergencies. The gentle climate of Grass Valley and its surrounding area meant plentiful food resources and therefore encouraged a greater population density. (John Carter Brown Library, Brown University.)

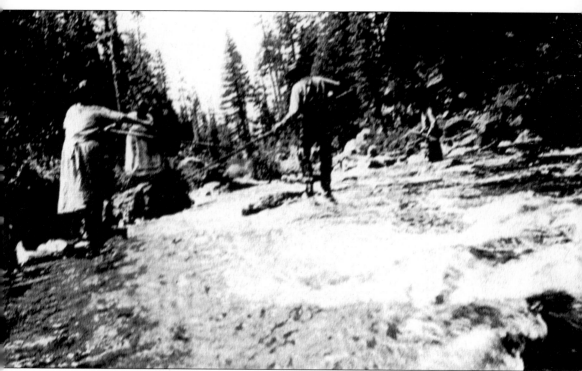

SOUTHERN MAIDU TERRITORY. This area offered abundant year-round food supplies. Extended families or whole villages would gather acorns, wild plums, berries, grapes, and other native fruits. Manzanita berries were often traded to Valley Nisenan or made into a cider-like drink. Deer drives were common, with several villages participating and the best marksman doing the killing. Antelope, elk, and mountain lions were hunted for food and for their skins. Grizzlies were greatly feared and never hunted, nor were owls, vultures, condors, or coyotes. Fish were speared as shown above, using very long spears with tips of hardwood that had been hardened by fire. That is how Rosie (left) and Frederic Chandler (right) are fishing with other family members in a Sierra creek, on this photograph, their spears tied to a rope so they could pull up the catch. The Chandlers were relatives of Richard Yemie, Chief Wemah's brother who was born in 1836. Their grandson Don Ryberg is today the Tsi-Akim tribal chairman. (California State Library.)

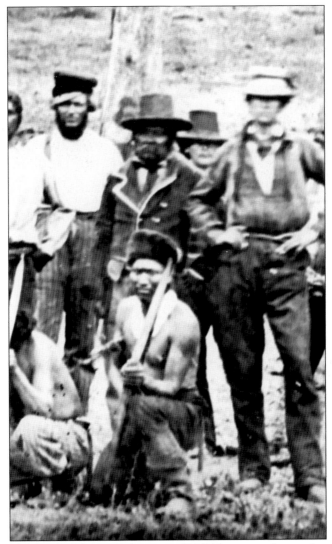

CHIEF WEMAH. The head of the confederation of Hill Nisenan tribes at the time of the Gold Rush and the most recognized Maidu in the 1850s and 1860s, Chief Wemah ruled over a territory bounded by the South Fork of the Yuba, the Sierra Nevada, the Bear River, and Johnson's Crossing. He occasionally camped in the Grass Valley area, but his main village was near present-day "Weimar"—named for him—off Highway 80. Wemah had learned a smattering of Spanish and English and a had pronounced liking for wearing a military jacket and bowtie, which helped historian Peter Shearer identify him on this rare photograph (see page 43). The Maidu elected their "capitans" in a democratic way on the basis of how much they were liked. Anytime their chief displeased them, tribal members exercised the right to remove him and substitute another by simply consulting with one another and agreeing upon the successor. This happened to Wemah after he tried unsuccessfully to lead his tribe through the devastating times encountered during the gold rush. (Peter Shearer.)

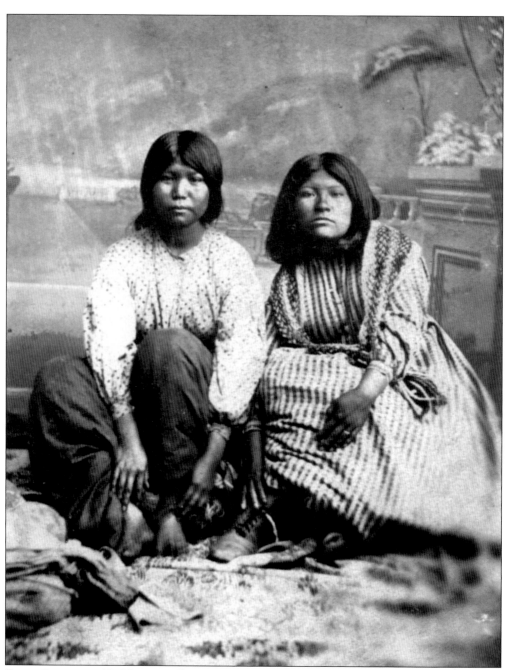

First Contacts. No Nisenan villagers appear in the baptismal records of Bay Area missions or in those of Mission Solano in the early 1800s. This means that the Franciscan padres' sweeps for new converts did not reach that far into Northern California. Neither were Grass Valley's Maidu affected by the terrible 1833 smallpox epidemic that destroyed so many valley tribes following the passage of John Work's scouting and trapping party. And Sutter's ferocious and profitable slave trade, which so outraged Gov. Juan Batista Alvarado in the 1840s, did not extend into Maidu territory. It was the extreme abundance of gold in their valley floor that ultimately brought tragedy and near-extinction to the early rulers of the Grass Valley area. (Searls Library.)

Two

GOLD RUSH BOOMTOWN

The first documented non-Maidu visitors to the Grass Valley area were members of an overland company that passed through in the fall of 1846, among them French-born pioneers Claude Chana, Charles Covillaud, and Eugène B. Vergé. Early historians recount how their wagon train overtook the Donner Party and how their descent was slowed from the Truckee Pass Trail by dragging fallen trees behind their wagons only two weeks before the storm that stopped the Donners's ill-fated train. The valley meadow kept green by year-round springs was discovered by the company's starved cattle after they broke away from their camp on Greenhorn Creek.

When news of the gold discovery reached Oregon's Willamette Valley, David Stump and two others trekked to the American River in the summer of 1848. On their journey back north, they found "a stream running through a fertile valley, whose luxuriant growth of grass and wild peavines refreshed their weary eyes." For three weeks, they successfully crevassed for gold at the location of the future Eureka and Idaho Mines until the approaching winter drove them from the mountains.

No one else is known to have visited the valley until August 1949, when an overland party of five immigrants—Benjamin Taylor, a Dr. Saunders, a Captain Broughton, and his two sons—built a cabin on Badger Hill. They were joined that summer by Zenas H. Denman, John Little, John Barry, and the Fowler brothers and in the fall by substantial groups of Frenchmen from San Francisco until, according to author Edwin Gudde, a "French Camp" appeared by the creek, probably in Boston Ravine.

These early gold diggers found fortunes using simple placer and hydraulic mining methods. Early historians Thompson and West estimated their combined gold harvest on Wolf Creek's flats and ravines through January 1855 to be $3.585 million. Then as they burrowed into nearby hills, miners uncovered new fabulous gold ore deposits. Although gold-bearing quartz held promise, it was a hazardous operation. Many of the early adventurers pocketed their "pile" and left. It would take another breed of miners to successfully extract the gold embedded in the valley's rich quartz veins.

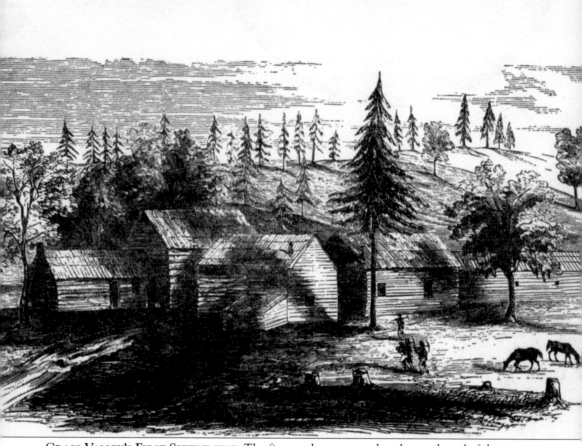

GRASS VALLEY'S FIRST SETTLEMENT. The first settlers appeared at the south end of the present Mill Street. The settlement was named Boston Ravine after a company of Bostonians headed by Rev. H. Cummings, who built four cabins on the west side of Wolf Creek in September 1849. In December, French gold digger Jules Roussière opened the first store, shown above, the second building from right. Roussière sold it the following spring to fellow Frenchman Bertrand L. Lamarque, who had prospected in Mexico and was the only experienced miner on Wolf Creek. The store became the miners' rallying point "for news and their grubstake," and Lamarque added a 10-pin bowling alley to it (the low building on the far right). Grass Valley remembered this pioneer Frenchman by later naming a street Lamarque Court. The hill in the background was named Isadore Hill after an African American miner who first discovered a quartz vein there. (Michel Janicot.)

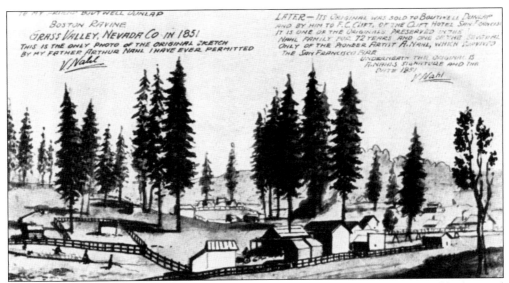

BOSTON RAVINE. This camp remained the area's chief settlement for two years and had started to look like a town by the time of the 1851 sketch above by German-born A. Nahl, brother of famous painter Charles Nahl. It rivaled Grass Valley for municipal leadership until the late 1850s, when the importance of the Marysville and Auburn Roads crossroad made that site more desirable. Today only one brick building at Mill and Empire Streets remains from this once-thriving community. Wolf Creek's rich gold deposits attracted hundreds of gold diggers, including groups of Englishmen, Irishmen, Germans, a few Italians, and a substantial number of Frenchmen. Although most were quite educated, they looked "like highway robbers, with their tall boots, flannel shirts, holsters and large hats," to French Navy officer Jean de Kerret, who sketched the placer mining scene below at Boston Ravine in October 1854. (Above California Historical Society; below Tugdual de Kerros.)

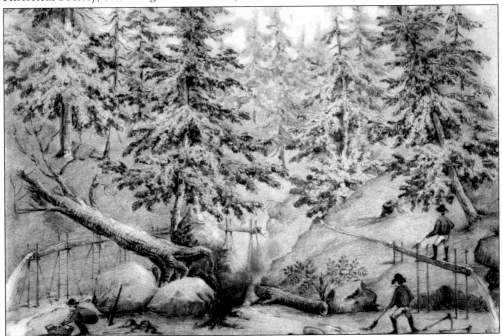

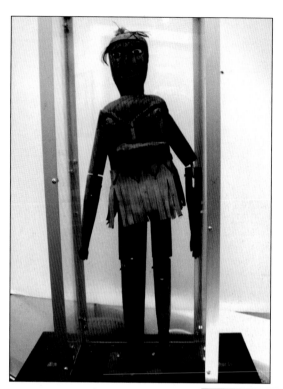

THE HOLT BROTHERS TRAGEDY.
In 1849, the California legislature enacted a law that deprived all Native Americans of property, citizenship, and voting rights. When two Maidu were killed for stealing cattle in May 1850, the tribe retaliated by burning the Holt brothers' sawmill outside Grass Valley, killing Samuel. Armed forces and miners "severely" punished the Native Americans and gathered survivors in camps pejoratively called "campoodies." It is believed that surviving brother George Holt carved this Indian doll. (Firehouse No. 1 Museum.)

PEACE TREATIES. In May 1850, July 1851, and still later, peace treaties that gave the United States legal title to the California Native Americans' lands in exchange for large reservations were signed by Indian chiefs, California representatives, and federal agents. When they reached Washington, the U.S. Senate had them placed in a sealed secret archive, which was not discovered for over 50 years. The Maidu did not receive a single acre of land.

Camp Union Treaty, July 1851.

Article 4: The US, in addition to the few presents made them at this council, will furnish them, free of charge, with 500 pounds, 200 sacks of flour, one hundred pounds each, within the term of two years from the date of this treaty.
Article 5: The following article will also be divided among them by the agent...: one pair of strong pantaloons and one red flannel shirt for each man and boy, one linsey gown for each woman and girl, 4,000 needles, one two and a half point Mackinaw blanket for each man and woman over 15 years of age, 4,000 pounds of iron and 400 pounds of steel, and in like manner in the first year, for the permanent use of the said tribes, and as their joint property: 75 brood mares and three stallions, 300 milch cows and 18 bulls, 12 yoke of cattle with yokes an chains, 12 work mules or horses, 25 ploughs, assorted sizes, 200 garden or corn hoes, 80 spades, 12 grinding stones.
Article 6: The US will also employ and settle among said tribes [for a period of five years, at the cost of the US], at or near their towns or settlements, one practical farmer,... with two assistants, one carpenter, one wheelwright, one blacksmith, one principal school-teacher and as many assistant teachers as the President may deem proper, to instruct said tribes in reading, writing...
The US will also erect suitable school-houses, shops and dwellings, for the accommodation of the school teachers and mechanics above specified and for the protection of the public property.

18

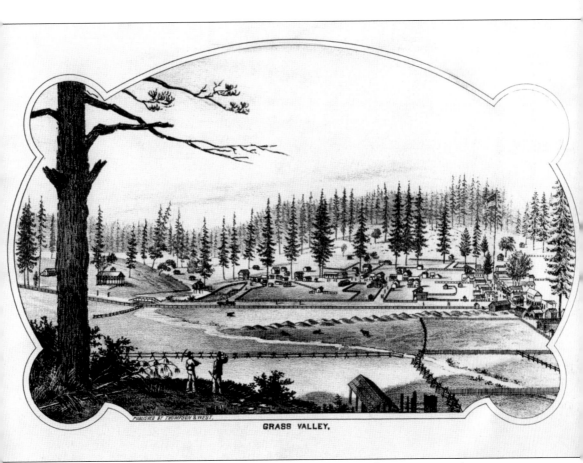

GRASS VALLEY.

CENTERVILLE. A town emerged at the other end of Mill Street, at the intersection of two important thoroughfares: a heavily-traveled wagon road from Marysville's steamer landings through Timbuctoo and Rough and Ready to Nevada City and the trail between Boston Ravine and Wolf Creek's gold camps. These became Main and Mill Streets. The first structure was a sawmill built in June 1850 by James Walsh, Zenas Wheeler, and G. P. Clark. The second was a Mr. Morey's store on Main Street. By November 1850, some 200 miners met beneath an oak tree on Mill Street, later the site of Lola Montez's cottage, to elect their first officials, casting ballots in a cigar box. They named their post office Centerville since it sat on the new postal route halfway between Nevada City and Marysville, the important towns of the day. This early image shows the creek meandering through large untouched meadows with homes mainly on Main Street on the right and Mill Street at the top. Auburn Street is already traced with a bridge built over Wolf Creek at Boston Ravine. (Leonard Berardi.)

CALIFORNIA'S SECOND GREAT GOLD DISCOVERY. In October 1850, a certain George McKnight, searching for his wandering cow, stumbled on a rock outcropping that revealed a vein of gold two feet wide. The story is apocryphal—the tale and name first appeared around 1900—but "Gold Hill" was not: it yielded a total of $4 million in gold between 1850 and 1857. Pictured above, the plaque on Hocking Street marks the site of the discovery that set the miners wild. A December 1850 newspaper reported that the Gold Hill vein was so rich that men merely using hammers obtained "lumps of gold" worth $1 each. Some found a fortune when they broke up the rock of their newly made fireplace. John Bartlett's survey artist Henry B. Brown sketched one of the "coyote holes" dug into Gold Hill in late 1850, shown below. (Author's collection, Bancroft Library.)

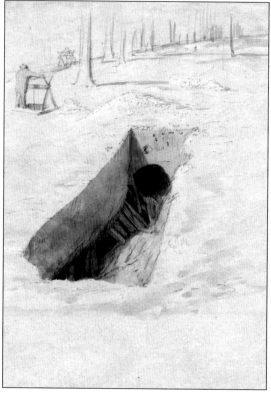

EARLY QUARTZ MINERS. By 1851, the hills were perforated with hundreds of holes 20 to 40 feet deep that resembled water wells. Lowered into the shafts inside these large buckets, quartz miners dug tunnels deep into the earth to follow, chip, and blast the gold-bearing quartz veins. Cave-ins were frequent, and tunnels were continuously flooded by springs. Every cabin now became a miniature quartz mill. (Bancroft Library.)

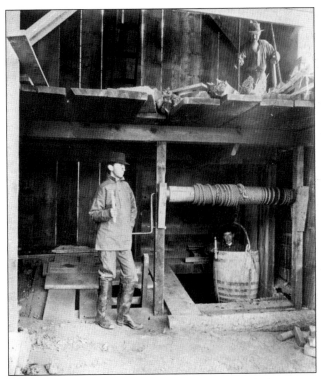

UNDERGROUND WORKINGS OF A MINE. Quartz mining quickly fell into disfavor due to the crudeness of early machinery, the precarious underground working conditions, and the inexperience of miners in extracting gold from rock. Forced to dig deeper and deeper to follow the vein and to acquire equipment to crush the rock and separate the gold, miners usually lost interest and sold out their claims. (Leonard Berardi.)

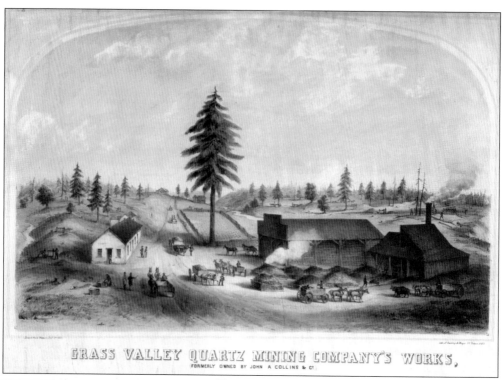

GRASS VALLEY QUARTZ MINING COMPANY'S WORKS,
FORMERLY OWNED BY JOHN A COLLINS & C.

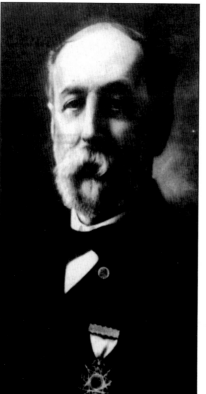

THE OPHIR MINE, A.K.A. EMPIRE MINE.
Lumberman George Roberts found gold on Gold Hill
only weeks after the legendary discovery. Using mere
hand tools, he and his successors excavated 2,000
feet of shaft but became discouraged and sold the
claim for $350 to Gilmor Meredith. When financier
William Bourn purchased it in 1869, the Ophir
was described as "the most magnificent" mine in
California. Five years later, the ore seemed exhausted.
(Bancroft Library.)

GILMOR MEREDITH. This Baltimore businessman
caught gold fever during an 1851 visit to Grass
Valley. He organized the Grass Valley Quartz Mining
Company with capital gathered in his home state
and proceeded to annex small claims throughout the
valley. Soon his mine averaged $1,000 a day. The
beautiful cottage he built that summer as a mine
office and residence captivated Lola Montez two
years later. (Comstock Bonanza Press.)

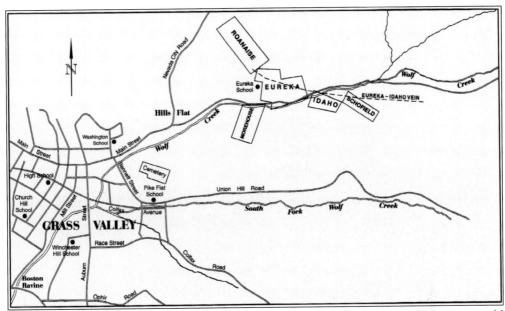

THE EUREKA MINE. First discovered in February 1851 by Bertrand Lamarque, the mine was sold six years later to Jules Fricot, Sidouin Ripert, and Alphonse Pralus. It required an infusion of capital by 1865, and the Frenchmen then found other investors to share in the expenditures. It became the leading gold-producing quartz mine in the United States from 1866 through 1871 with a total production of $5.7 million. The rich vein was lost in 1877. (Comstock Bonanza Press.)

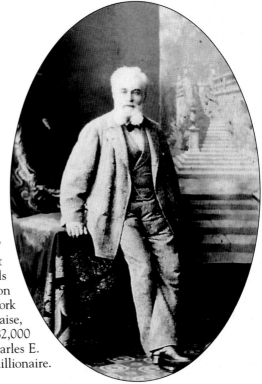

JULES FRICOT. Also known as the "Emperor" for his resemblance to Napoleon, Fricot first reached Grass Valley with boyhood friends André and Louis Chavanne in 1850. He soon struck it rich, reaping $300,000 from the New York Hill mine. A co-owner of the Eureka, Roannaise, and Idaho Quartz mines, Fricot enjoyed $182,000 in income in 1865. A brother-in-law to Charles E. Clinch, Fricot returned to France in 1873 a millionaire. (Michel Janicot.)

NORTH STAR GOLD MINING CO.

GRASS VALLEY NEVADA CO.

This Certifies San Francisco June 1st, 1868.

that *E. A. Hartendine.*

is entitled to *Seventy three (73)* Shares

in the Capital Stock of the **NORTH STAR GOLD MINING CO.**

Transferable on the books of the company by indorsement hereon and surrender of this Certificate.

SECRETARY PRESIDENT

THE LAFAYETTE, A.K.A. THE NORTH STAR. The French Lead Mine was first discovered in 1851 below Boston Ravine by French-Canadian Henri Lavanche. It was purchased in 1860 for $15,000 and renamed North Star by John and Edward Coleman. The brothers added a 16-stamp mill and dug the main shaft to 750 feet, earning $500,000 in profit between 1860 and 1867. It was considered "played out" by 1884. (North Star Mining Museum.)

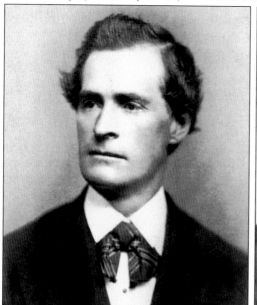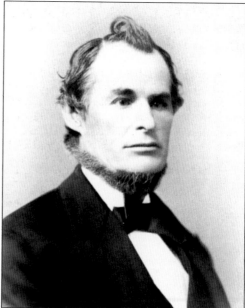

THE COLEMAN BROTHERS. Born in England and raised in Canada, these expert businessmen headed for California in 1853 and became major owners and investors of the North Star, the Idaho Quartz mines, the railroad, and lumber companies among others. Legend says they never disagreed except over politics: one was Republican, the other Democrat. They lived long lives and built fine homes in Grass Valley. (Persis Coleman.)

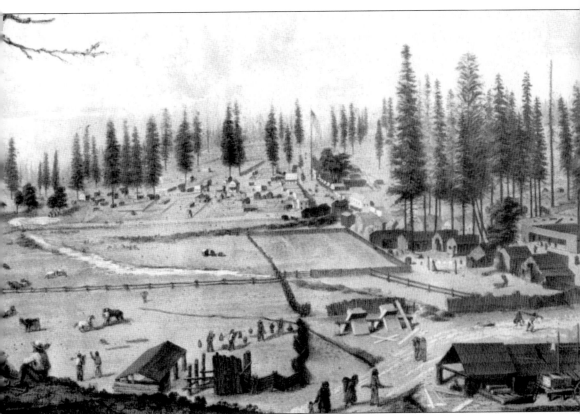

RUSH TO GRASS VALLEY. In January 1851, there were only three or four cabins in Grass Valley proper, but according to *History of Nevada County with Illustrations*, by March 1851, there were already 150 wood or canvas structures, several stores, hotels, saloons, and shops—all surrounded by "coyote holes." Grass Valley started to look like a real town, with a school, a post office, and churches, and it began to take a prominent place among the county's mining camps and boomtowns. Its first newspaper appeared in 1853, and the first plat map showed 12 mills, 5 hotel-boardinghouses, a Masonic hall, and a building housing the Adams and the Wells Fargo Express Companies. Grass Valley's first white child, Selena Bice, was born in August of that year. This sketch by Augustus Koch shows on the right foreground a lumber mill, which remained in that same location until 1976. While gardens have appeared toward Henderson Street, much timber has vanished from the hills. Gold panners watch the scene in the foreground; token Indian natives and Chinese peddlers with long bamboo poles appear on the dirt road. (Bancroft Library.)

ALONZO "OLD BLOCK" DELANO.
This New York merchant and member of the French Huguenot Roosevelt-Delano family answered the call of gold in 1849. He became Grass Valley's first Wells Fargo agent and a famed humorous writer whose sketches of gold camp life rivaled those of Bret Harte and Mark Twain. He was a friend of Simmon Storms, Chief Wemah, and Lola Montez. (Wells Fargo Museum.)

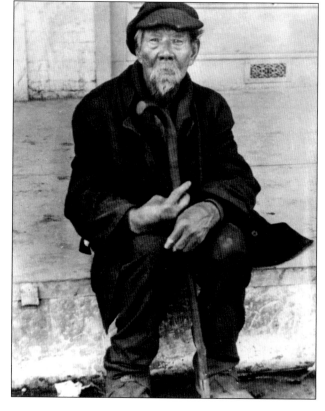

GEE YUEN, A.K.A. "DUCK EGG." Locally called Ah Chee, he was one of the thousands of Chinese drawn to California by the promise of wealth. He became Alonzo Delano's lifetime friend, cook, and valet and earned national attention in his old age when schoolboys who had pelted him with rocks and eggs mailed him money to ease their guilt as adults. His 1918 portrait by Doyle Thomas was subsequently printed as a postcard. (Jim Johnson.)

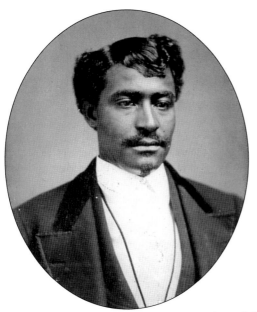 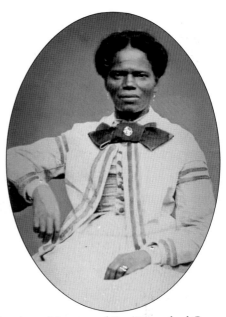

THE HENDERSENS. Boz, his wife Hannah, and their daughters Minnie and Fannie reached Grass Valley in the early 1850s as servants to the Conaway family. There were enough African Americans in early Grass Valley that an African Methodist Episcopal church was erected in the summer of 1854, and a "colored" school opened on South Auburn Street. A "Colored People's Festival" celebrated the second anniversary of Lincoln's Emancipation Proclamation in 1865. (Carl Mautz.)

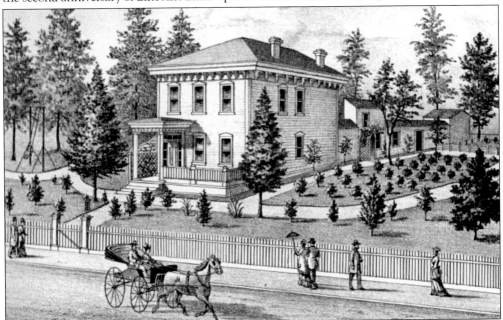

JAMES C. CONAWAY. This Maryland native first came to Grass Valley in the early 1850s. After investing in the Helvetia and Lafayette Hill Company and bankrupting, he created the successful Patterson and Conaway lumber company. He and his wife, Ida, made the news when they installed the first flush toilet in Grass Valley in their beautiful South Auburn Street residence. Conaway Street was named for him. (Leonard Berardi.)

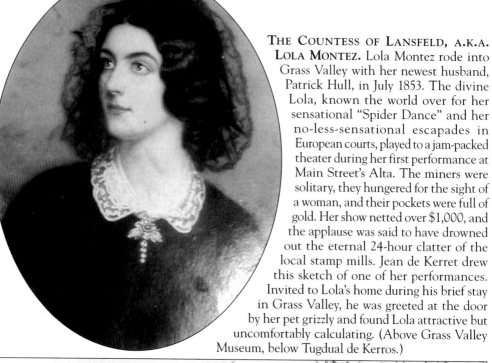

THE COUNTESS OF LANSFELD, A.K.A. LOLA MONTEZ. Lola Montez rode into Grass Valley with her newest husband, Patrick Hull, in July 1853. The divine Lola, known the world over for her sensational "Spider Dance" and her no-less-sensational escapades in European courts, played to a jam-packed theater during her first performance at Main Street's Alta. The miners were solitary, they hungered for the sight of a woman, and their pockets were full of gold. Her show netted over $1,000, and the applause was said to have drowned out the eternal 24-hour clatter of the local stamp mills. Jean de Kerret drew this sketch of one of her performances. Invited to Lola's home during his brief stay in Grass Valley, he was greeted at the door by her pet grizzly and found Lola attractive but uncomfortably calculating. (Above Grass Valley Museum, below Tugdual de Kerros.)

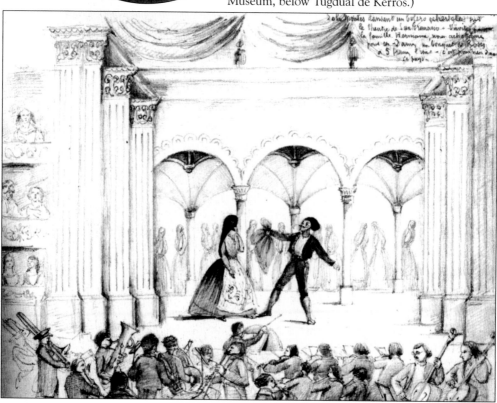

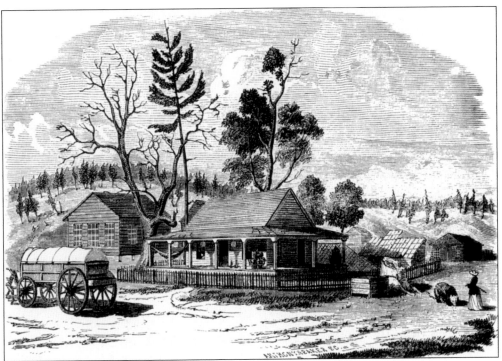

LOLA'S COTTAGE. Lola fell in love with the rude mining camp full of bright young bachelors. She bought Gilmor Meredith's cottage and acquired an odd menagerie of animals, including a grizzly, visible in this sketch. Dressed in glittering attire, she held weekly salons financed by merchant John Southwick until she left for Australia in May 1855. Her cottage is today home to the Grass Valley Chamber of Commerce. (Comstock Bonanza Press.)

LOTTA MIGNON CRABTREE. The nearly-six-year-old Lotta moved with her parents to Grass Valley in 1853, close to Lola Montez's cottage. However, historian Doris Foley believed it was not Lola but local child star Sue Robinson who inspired Lotta's singing and dancing tour of the Sierra mining camps that same year, a tour that launched her stellar career: Lotta became the highest paid American actress of the day. (LaVonne Mullin.)

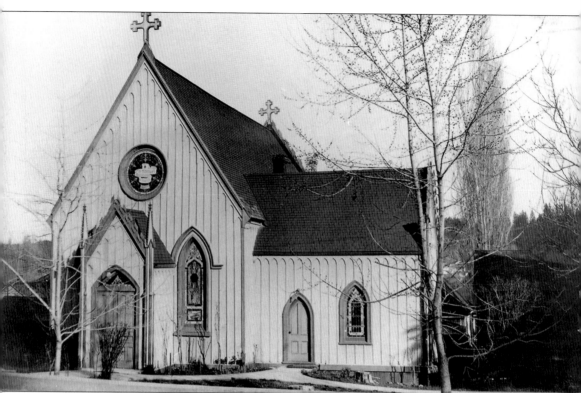

THE EMMANUEL EPISCOPAL CHURCH. This is one of the several churches built in Grass Valley early in the 1850s, along with St. Patrick's Catholic Chapel, a Congregational church, and a Methodist church. According to historian Gage McKinney, the first Mass celebrated at Emmanuel Episcopal Church fell near the Feast Day of the Annunciation, commemorating the day the Angel Gabriel told the Virgin Mary that her son would be called Emmanuel, meaning "God is with us." The church building, which still stands at 245 South Church Street behind the Lola Montez cottage, was erected in 1858 at a cost of $6,500. The land had been donated by the Gold Hill Mining Company in December 1856 on condition that a church be erected within 18 months. It is the oldest Episcopal church and rectory in the Northern Mines area and one of the oldest religious edifices in the Northern mines. (Jim Johnson.)

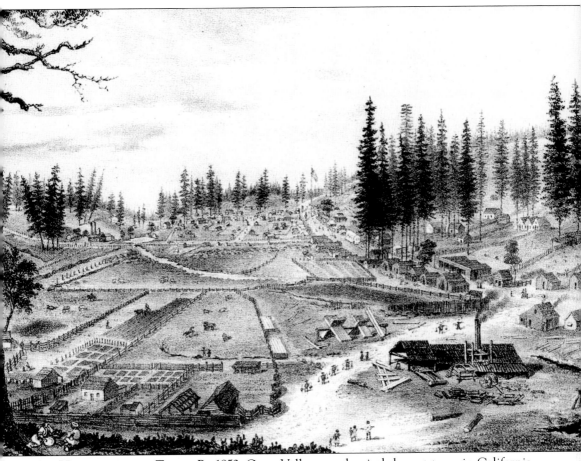

AN UNPRETENTIOUS TOWN. By 1853, Grass Valley was the sixth largest town in California behind San Francisco, Sacramento, Marysville, Stockton, and Nevada City. In this unpretentious village of wooden buildings and tents, churches were constructed on Church Street and schools on School Street, while roads were fine dust in summer and mud in winter. Local newspapers deplored the absence of a cemetery, as well as the presence of over-enthusiastic miners who dug holes in the streets or undermined the foundations of houses in their quest for gold. A brick kiln built in 1854 boosted the city's growth, and a few brick buildings appeared, the first at the corner of Main and Mill Streets to house the Adams Express Company and then a fireproof brick vault built by Delano for the Wells Fargo Company. Missionary William Ingraham Kip described the town as lively, noisy, and industrial: the ground shook day and night from the stamp mills, chickens and barking dogs ran loose, roosters crowed at day break, foraging cows with bells raided gardens, and boisterous or drunken saloon and brewery patrons wandered amidst it all. Note the gardens near present Henderson Street. (Bancroft Library.)

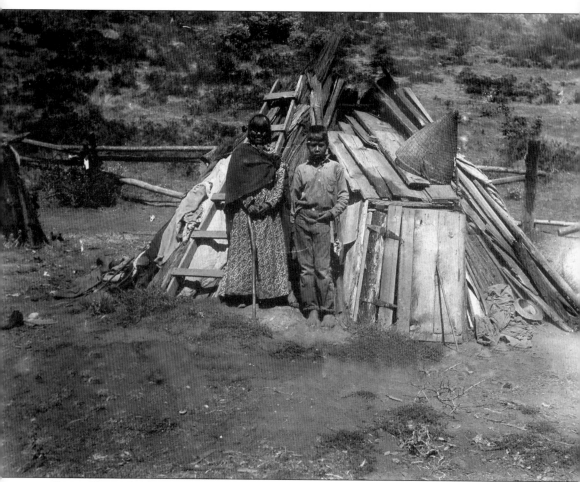

GRASS VALLEY'S MAIDU. The local Maidu had little time to adjust to the rapid white encroachment on their territory. They found it unaccountable that the acorn crop failed three years in a row. They believed evil spirits were at work, but they had no traditional ceremony to fight them. As the town expanded, so did their plight. Many became sick from eating spoiled meat from butcher pens or dead immigrant cattle. Without regular hunts, the men turned indolent, camps were erected carelessly, and they showed less respect for their chiefs. They became habitual users of "ardent spirits" traders sold them illegally. The squaws went on picking potatoes in farms and crevassing for gold on the streams, but half of them were in mourning, and "lewdness" appeared among the younger ones. "Despair sits brooding upon their countenances," federal investigator W. F. Crenshaw wrote. "In their present location they will be blotted out of existence." He estimated the Nisenan population had decreased by 50 percent between 1848 and 1854. (Jim Johnson.)

SIMMON PEÑA STORMS. Storms left Boston for California in 1849 with 150 men including French Canadian David Bovyer. The son of a Cape Cod captain, Storms grew up in Venezuela and developed a gift for languages. He and Bovyer quickly learned native tongues as they traded on the Yuba River with both Native Americans and whites. Appointed special Indian courier and interpreter, Storms acquired a ranch in present Chicago Park and in 1852 persuaded Chief Wemah to host a grand "yomashee" there to show the locals the ancestral Nisenan ways. The Maidu's athletic feats and dances greatly impressed the spectators. Historian David Comstock believes Storms was one of the few agents who behaved honorably toward Wemah's people, while Bovyer talked them into getting vaccinated. Storms's buckskin suit, wallet, and money belt are on display at the Grass Valley Museum. (Grass Valley Museum.)

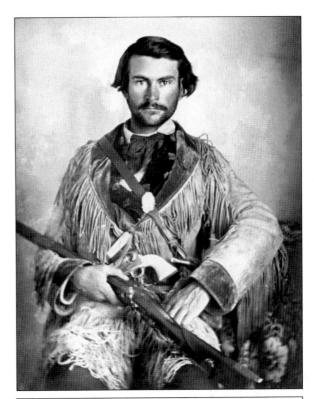

EXTRAORDINARY
Attraction!
ONE . THOUSAND
INDIANS
With their War Implements, Squaws, Papooses, &c.
WILL ASSEMBLE

At Storms' Rancho,

On the Illinoistown road, six miles from Grass Valley and 6 1-2 from Nevada, on the afternoon and evening of Monday, July 19, 1852, for the purpose of

Celebrating their Annual Feasts and Fancy Dances.

This will be one of the largest Indian collections that has ever taken place in California, and

To those who have never witnessed any thing of the kind,

IT IS WELL WORTH
The Ride.
CAPT. WEYMEH.

Storms' Rancho, July 11, 1852.

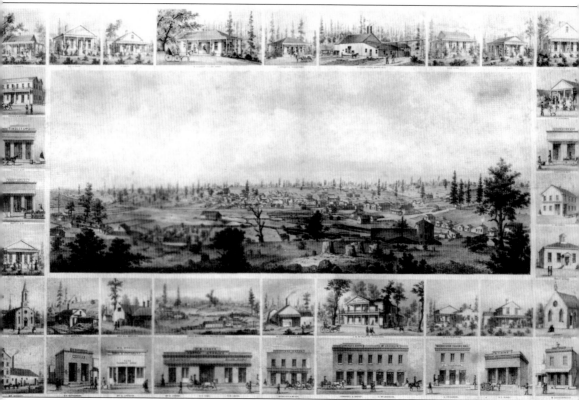

BIRTH AND INCINERATION. On March 5, 1855, the town of 3,500 souls incorporated and elected city officers, among them J. J. Dorsey, a marshal, an assessor, a city clerk, and Alonzo Delano as treasurer. The law used to incorporate was later declared unconstitutional, and new incorporations were made in 1860 and 1870. Like all boomtowns, Grass Valley was a kindle box: all residents were required to keep 50 gallons of water per house and four fire buckets for each story. On September 13, 1855, flames spread from Madame Bonhore's hotel at Main and Auburn Streets, burning 30 acres and 300 shops and homes, with an estimated loss of over $400,000. Agent Delano became a legend when all documents and money were found intact inside his Wells Fargo safe, recently built of bricks. The churches, Lola's cottage, and a few brick buildings survived including the Adams and Company structure on the upper corner of West Main and Mill Street, Grass Valley's oldest brick building. A recent documentary immortalized the fire, using a condemned movie set in the wilds of Arizona. This was how the town looked three years after the fire. (Bancroft Library.)

Three

QUARTZ QUEEN
OF THE WEST

The fire of 1855 wiped out the rough gold rush camp. A stronger, more beautiful town emerged, soon dubbed by the press "Quartz Queen of the West." Residents rebuilt homes and stores with brick and erected a reservoir on Alta Hill to supply the town with piped water. Main and Mill Street were cleared of rubble and filth, re-graded, and planked as shown on our cover photograph. The town was first illuminated on September 27, 1862, with gas made of pitch pine and stone coal. These improvements induced more families to locate permanently in Grass Valley than was common in mining towns. The town grew from 3,840 in 1860 to 6,000 in 1865.

Social and recreational activities centered on churches, theaters, lodges, and clubs, not to mention billiards, bowling, concerts, and lectures. According to historian David Comstock, Bertrand Lamarque taught well-attended dance classes in the 1850s and 1860s. There was also a medical association "for the purpose of advancing the interest of medical science in Grass Valley," as well as Masonic and Odd Fellow lodges (David Bovyer was an early member), Good Templars, and Sons of Temperance.

Following the discovery of rich quartz veins on Gold Hill, Grass Valley's gold output dwarfed Nevada City's productivity. A galaxy of mines, each with its own shafts, stamp mill, and office, appeared around Grass Valley. Their names—Eureka, Allison Ranch, North Star, Brunswick, and Empire—remain familiar today. Inevitably, the mines had a destructive impact on the environment, a fact that was criticized in the *Grass Valley Telegraph*: "The valley of Wolf Creek, from which our quiet village takes its name—a beautiful valley once green and meadow-like with the forest of tall pines on either side: what is it now, but a vast field of ditches and shafts, and piles of dirt, with sluices and toms, and windlasses and engines puffing and pumping covering its surface." Intense lumbering defaced the valley as well: 2,000 to 3,000 feet of lumber were turned out daily by the valley's mills.

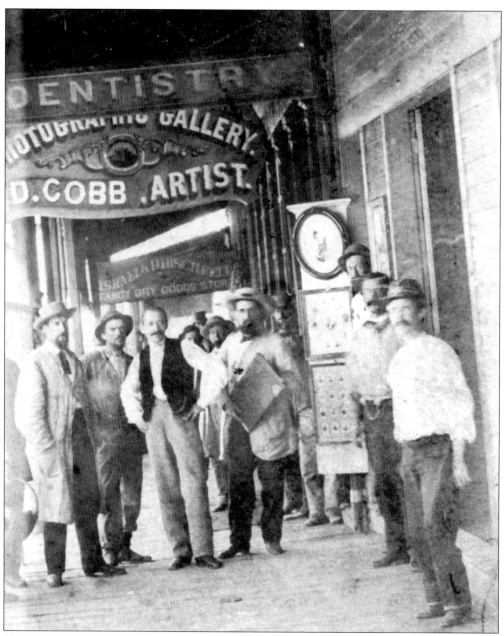

THE NEW ART OF PHOTOGRAPHY. The booming West was now being chronicled in photography. Among the earliest photographers were George S. Lawrence and Thomas Houseworth, former opticians turned photographic publishers who sponsored an extensive photographic expedition throughout California in the summer of 1864, including four early Grass Valley views shown in this volume (cover and pages 37, 38, and 48). David Cobb, shown here, was another early photographer who opened shop in Grass Valley between 1866 and 1867, above Dr. Harris's drugstore on Mill Street. Cobb specialized in small photographs produced "with exactness," in his words. They included portraits of native Maidu and other locals (see page 14). He later joined French-born Alexander Edouart to create a photographic gallery, which operated in San Francisco from 1869 to 1881 when Edouart moved to Los Angeles. (Searls Library.)

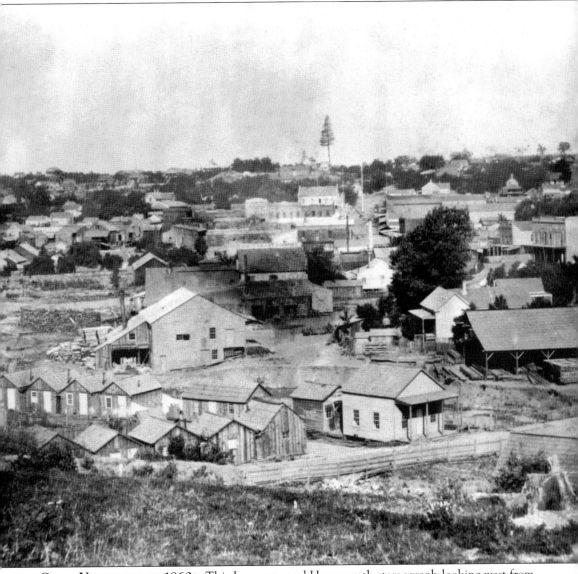

GRASS VALLEY IN THE 1860s. This Lawrence and Houseworth stereograph looking west from Cemetery Hill shows the Grass Valley Foundry, center; West Main as a planked street at top right; and brick buildings later part of "The Waterfront" on the right. The lumberyard on the right, which was for a long time Lewis Fowlers's Grass Valley Lumber Company, remained at that location at the corner of Main and Bennett Streets from the earliest days until it was replaced by the post office in 1976. Due to the multiple uses of timber needed daily for fueling the stoves, timbering the mines, powering the steam pumps, and building homes, few trees are left around the town. (Jim Johnson.)

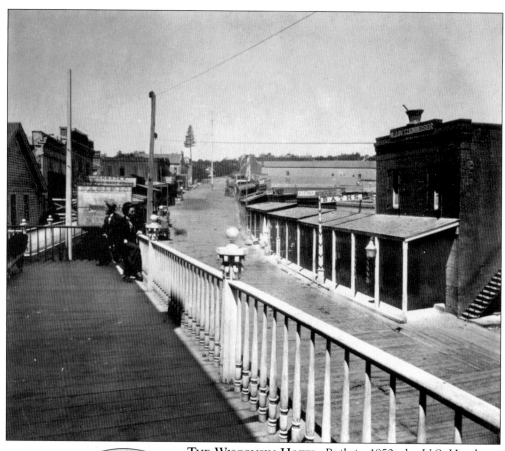

THE WISCONSIN HOTEL. Built in 1850, the U.S. Hotel was twice destroyed by fire in 1855 and 1860 and became the Wisconsin Hotel. The above 1860s view from its terrace looks up from South Auburn Street at West Main and its planked surfaced. In the 1890s, Douglas S. Riddle turned the Wisconsin into a first-class hotel. Later named the Fillmore, it was razed in the 1940s to make way for a gas station and became today's city hall parking lot in 1973. The mortar-and-pestle sign on the right tops William Loutzenheiser's pharmacy, which existed from 1855 to 1928. An Ohio native, Loutzenheiser (on the left) first worked for pioneer druggist McCall from 1851 until the fire of 1855; he then built his own brick pharmacy, Grass Valley's fourth oldest brick building, at the corner of Auburn and Main Streets. (Society of California Pioneers, Leonard Berardi.)

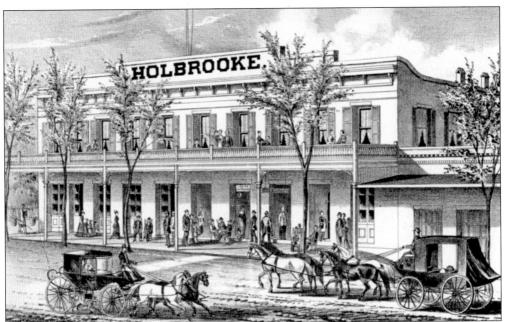

THE HOLBROOKE. Destroyed in the fire of 1855, the "Golden Gate Saloon" was immediately rebuilt in Victorian style with copper-clad walls, original mahogany wood, and Italian alabaster and marble and incorporated into the "Exchange Hotel" built by C. W. Smith in 1862. Renamed the Holbrooke for its new owner in 1870, it was described as "one of the best hotels east of Sacramento with 65 rooms, electric lights, gas, laundry, hot and cold water baths, express and telegraph offices opposite and free bus to hotel." One of its great visitors was a humorous, informative lecturer on the Sandwich (Hawaiian) Islands, 30-year-old newspaper writer Samuel Langhorne Clemens, a.k.a. Mark Twain, who lectured to a packed audience at Grass Valley's Hamilton Hall. Twain, pictured at right, was a friend of local journalist "Lying" Jim Townsend, featured in one of his stories. (Leonard Berardi.)

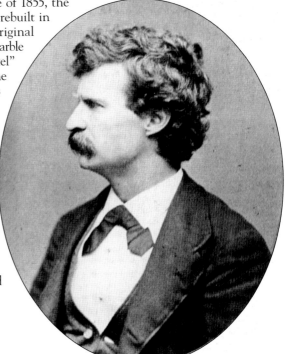

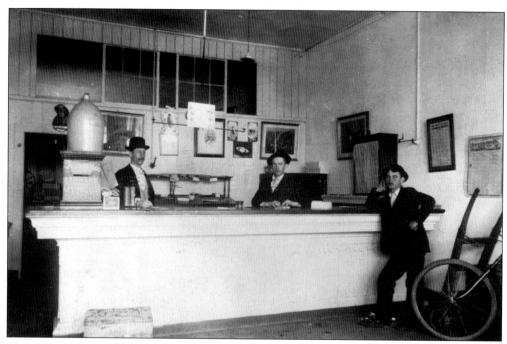

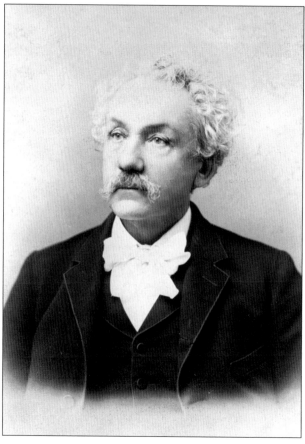

SAMUEL PACKWOOD DORSEY.
Starting in April 1857 and for 52 years, Grass Valley's Wells Fargo office was run by Samuel Dorsey, the first agent to put armed guards, or "shotgun" messengers, on coaches traveling routes plagued by robbers, like the road from Grass Valley to Colfax. The 1890s photograph above shows his gas-lit office manned by two clerks and a "wheel man" or bicyclist. The son of a rich New Orleans plantation owner, Dorsey was schooled in English, French, and Spanish and enjoyed reading American and French newspapers each day. He was a shareholder in the Idaho mine, a school trustee, and a Mason. He lived on South Church with his wife, Eliza Sparks St. John, until the age of 90. At a time when most gold was melted for coinage, Dorsey collected gold specimens from local mines. Wells Fargo History Museum acquired this valuable collection in 1974. (Wells Fargo History Museum.)

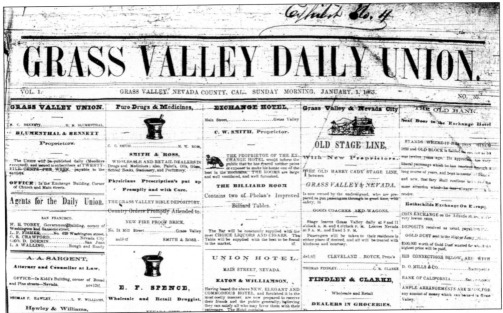

THE GRASS VALLEY DAILY UNION. The *Grass Valley Daily Union* started as the town's first Republican newspaper on October 28, 1864, 11 days before the presidential elections pitting Gen. George B. McClellan against Abraham Lincoln. Founding editor Jim Townsend was accused of betraying his Republican backers when he proposed to sell out to the opposition party only four days before the vote. John Rollin Ridge was implicated in the deal. In *Sierra Songs and Descants,* author David Comstock comments that the *Union* was unsuccessful under Republican management but turned outright prosperous when purchased by the Democrats in the mid-1860s. The paper was housed in the Adams Express building from 1871 to 1903. (Above *The Union;* below Leonard Berardi.)

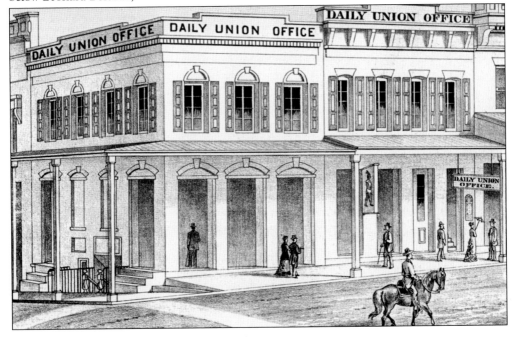

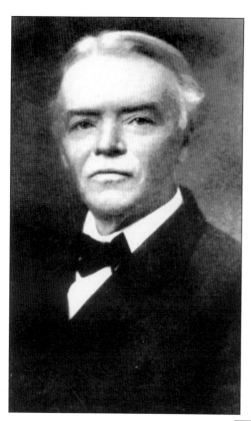

JOSIAH ROYCE. This renowned philosopher maintained that his 11-year boyhood in ruggedly independent Grass Valley left a lasting mark on his life and thinking. He was born at the Mill Street house his parents built at the end of a 2,000-mile, six-month overland odyssey his mother, Sarah, later recounted in her memoirs. His home today is the site of the Josiah Royce Public Library. Royce graduated from the University of California in 1875, earned his doctorate at Johns Hopkins, and taught at Berkeley and then at Harvard from 1882 until his death in 1916. (Comstock Bonanza Press.)

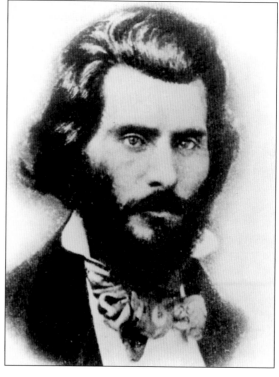

JOHN ROLLIN RIDGE. Also known as Yellow Bird, Ridge was the son and grandson of powerful Cherokee chiefs. Sadly, most of his kin were killed for signing a treaty with the United States. A very literate man educated at mission schools, Ridge lived his last days in Grass Valley as editor and part owner of the *Grass Valley National* from 1864 to 1867. His 1854 masterpiece *The Life and Adventures of Joaquin Murrieta* was the first novel published in California. (California State Library.)

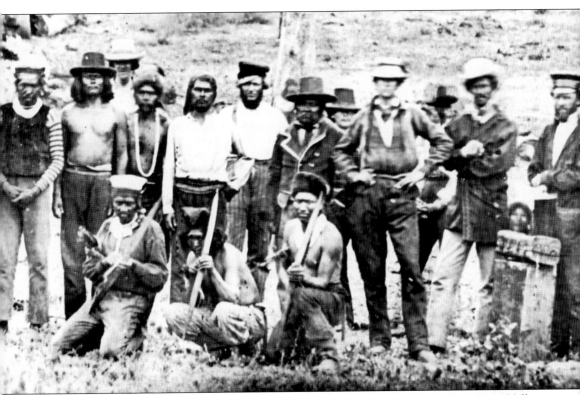

Exiled to Reservations. The fate of the Maidu created endless controversy in Grass Valley in the late 1850s and early 1860s. Some, like Alonzo Delano, trusted that government treaties would be enforced and that reservations could best protect the natives from diseases, whiskey, brutality, humiliation, and poverty. White traders who sold huge amounts of goods to them opposed this plan, as did the few who believed the Maidu's land should be purchased from them as was done on the East Coast. By October 1854, the majority of Nevada County's citizens encouraged the removal of hundreds of Maidu to reservations like Nome Cult, near Tehama, where this photograph was taken. The last Nevada County Native Americans were herded to Mendocino County's Round Valley Reservation in 1864. The Maidu trickled back to their homeland, Wemah among them, according to historian David Comstock. Today's Tsi-Akim tribal office in Grass Valley is dedicated to the preservation and perpetuation of the Maidu people's language, culture, history, and heritage. The Nevada County Historical Society gave the tribe an acre of land in 2000. (Pat Shearer.)

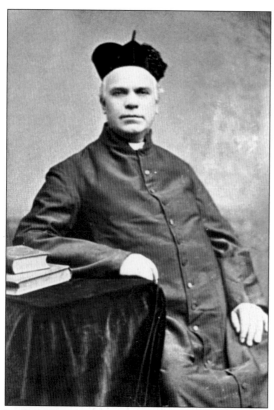

ST. PATRICK'S. Grass Valley's Catholics first worshipped in a wood chapel erected in 1853 by Fr. John Shenaghan at the corner of Church and Chapel Streets on the cemetery lot. His successor, Irish-born Thomas J. Dalton, traveled from Ireland to San Francisco and its gold camps, where between 1855 and 1858, he initiated and supervised construction of mission churches at Goodyears Bar, Sierra, Auburn, Cherokee, Moore's Flat, Forest Hill, Nevada City, and finally in Grass Valley in 1858. The imposing, brick, "modern-style Gothic," structure, pictured at left below, cost $35,000 and stood where St. Mary's parking lot is now located on Gold Hill. Considered the finest church edifice north of San Francisco, it was destroyed and replaced in 1950 for safety reasons. Father Dalton served as St. Patrick's pastor for 36 years until his death in 1891; a small street next to the orphanage was named for him. (Grass Valley Museum.)

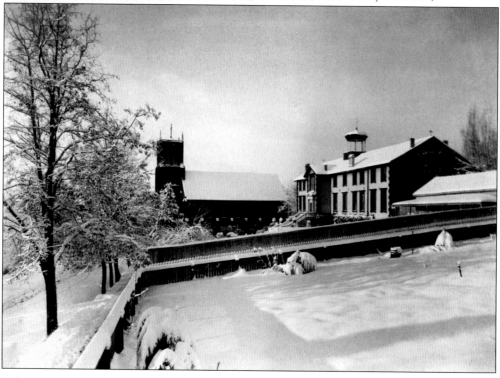

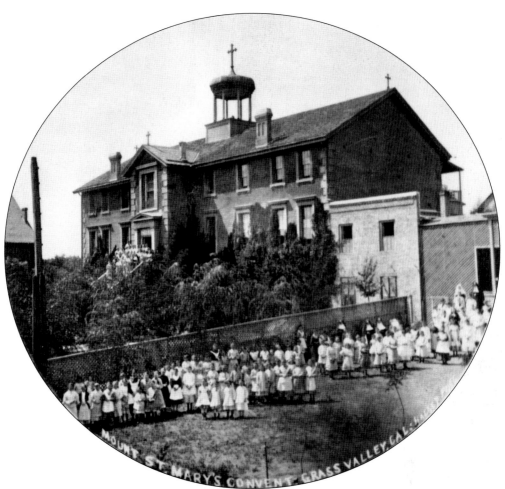

MOUNT ST. MARY'S, C. 1872–1875. Father Dalton founded a school with 66 girls and 43 boys and, in 1863, the Convent of the Sacred Heart for the Sisters of Mercy, who were greeted upon their arrival that year by the peal of church bells. Mindful of the many fatal accidents in the mines and the widows left to raise children on their own, Father Dalton also founded an orphan asylum. Modeled after the San Francisco Catholic Orphanage Asylum on Market Street, it was constantly filled. The building above was completed in 1866. To support the orphanage, a "select school for young ladies" was opened in September 1868 where girls from wealthy families were taught English, French, and German, and vocal and instrumental music. Today Mount St. Mary's offers Catholic education, while the former St. Joseph's School for Girls serves as a community center. The convent closed in 1965 and became the Grass Valley Museum. The restored school and orphanage includes an original classroom, parlor, music room, doctor's office, and memorabilia from Grass Valley's early days. (Grass Valley Museum.)

GRASS VALLEY'S CHINATOWN. Thousands of Chinese laborers, laid off after completion of the transcontinental railroad in 1869, wandered through California in search of work. In Grass Valley, they engaged in placer mining at first, but barred from the hardrock mines, they turned to farm or domestic labor, ran laundries along Wolf Creek, or kept vegetable and fruit gardens near Colfax and Henderson Streets. Balancing wicker baskets on long bamboo poles, some Chinese peddlers brought fresh vegetables to the rear door of local homes. A Chinatown consisting of two rows of clapboard houses sprang up between Bank, Stewart, Auburn, and Bennett Streets. Its 1869 "Hou Wang Miao" temple—decorated with teak, embroidered trappings, leaf gold, and priceless carved images of gods and goddesses—can still be seen at Nevada City's Firehouse No. 1 Museum. (Above Alice Tinloy Yun; below Wally Hagaman.)

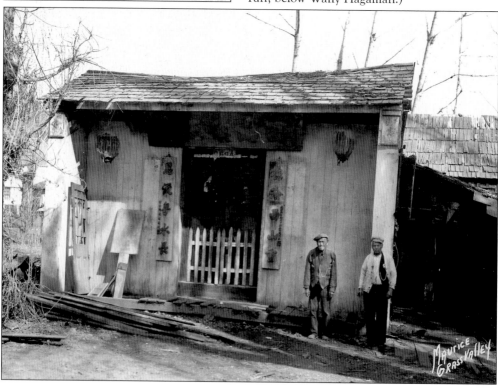

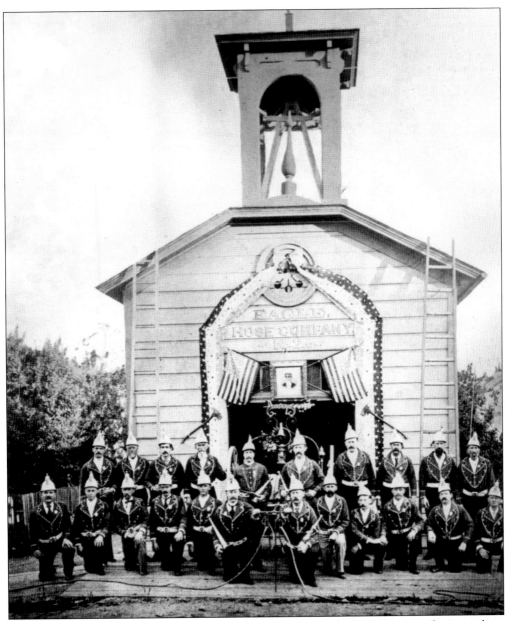

THE EAGLE HOSE COMPANY NO. 2. Organized in 1866, the Eagle Hose Company four years later erected this small firehouse, which still stands at 139 East Main Street but without its belfry and bell. Grass Valley's first firefighter's organizations were hook and ladder companies in the 1850s. They were not sufficiently equipped to prevent fires in their town built of wood and canvas. Conflagrations destroyed much of Grass Valley in March 1855 and August 1860. Two fires in 1862 caused a loss of about $64,000, including the old engine house, but Grass Valley's firefighters became better prepared and there were few fires after that date. Still, arson almost incinerated Chinatown in 1877. Its Chinese residents then built a tall tower on one of the homes and hired a watchman to keep vigil from midnight to 4:00 a.m. each night, striking the gong every hour to mark time and assure those in Chinatown that all was well. This was a familiar sound to all Grass Valley residents for many years. (Jim Johnson.)

UPPER MAIN STREET. Main Street looks more like a thoroughfare than a street on this 1860s stereograph. In contrast with the spectacular view on our cover, the street's top portion still remained quite unfinished, except for the cottages on the left hand side, which still exist today on what is known as Nob Hill. The ridgeline in the background clearly shows the vast decimation of the valley's forests. This is how the town looked to celebrities like Mark Twain, or to virtuoso pianist L. Moreau Gottschalk who called Grass Valley "a veritable garden, prim, attractive, joyful and full of flowers." It inspired Alonzo Delano to write, "As you descend the gentle full tilt through the Main Street, a multitude of neat houses and stores meet your eyes, all new as if they had just risen from the sawmill and been beautified by the painter's brush." The homes were in fact built with freshly cut lumber, which did not resist heat and moisture well and warped quickly. The *Nevada National* reported that some of the gardens had windmills for irrigation. (Carl Mautz.)

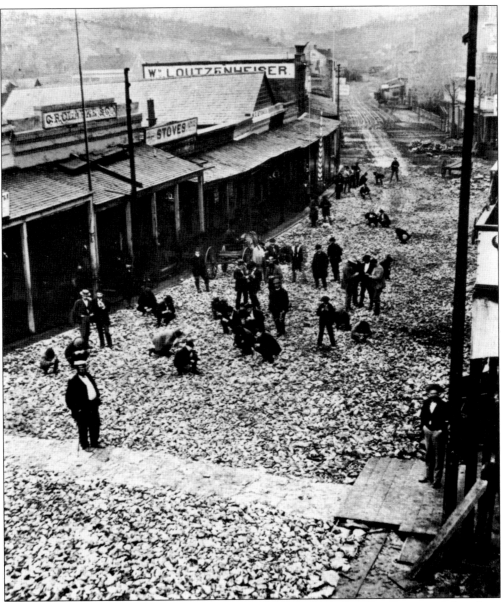

PAVED WITH GOLD. The 1880 *History of Nevada County with Illustrations* reported that there was quite a revival of placer mining in the 1870s, owing to the success of the Hope Company, who sank a shaft 200 feet down and struck a very rich old river channel. In the fall of 1874, this general excitement carried over, as related in an 1895 souvenir booklet, when waste rock from the dump of the Dromedary mine on the banks of Wolf Creek was spread on Main Street for "macadamizing purposes." Rain fell soon after and cleaned the rock until small flecks of gold became visible in the quartz: pieces of high-grade ore were mixed in with the waste material. Forty to fifty men and boys who happened to be nearby started to pick over the ore, hunting for gold-incrusted pieces with good luck, before traffic splattered mud. A photographer was there, too, fortunately. Reports in the press the next day stated, "A number of excellent specimens were revealed by the freshet. . . ." The Loutzenheiser sign is clearly visible at the corner of Auburn Street. (Jim Johnson.)

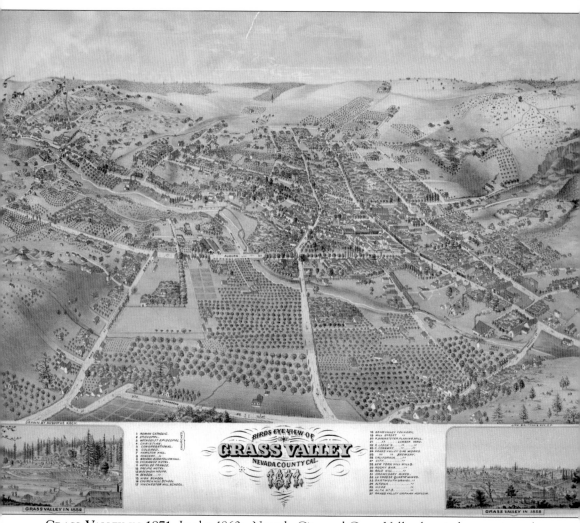

GRASS VALLEY IN 1871. In the 1860s, Nevada City and Grass Valley boasted approximately the same population, respectively 4,040 and 3,940. By 1870, Grass Valley dominated with a population of 7,063, while Nevada City trailed with 3,996. This map provides an excellent view of the town, with few trees but many orchards, with a growing Chinatown near the center and a "hydraulicked" ravine created by water canons on the right at the top of North Church Street. A river bend and bar mark the place where the Golden Center mine would appear, and the hamlet of Boston Ravine is clearly marked on left. The numbered caption refers to churches (including a "colored" church), the Hotel de France, and the Conaway lumberyard. The narrow gauge appeared five years later and was drawn in on the map on page 72. (Bancroft Library.)

Four

HARDROCK GIANTS AND ENTREPRENEURS

By the 1870s, Grass Valley was, according to all reports, without a peer in the mining world. It appeared to observers as both a gold rush town and a New England mining town, at once boisterous and businesslike. Although its number one industry was mining, fruit growing and packing came second with agriculture and the production of hay in third place just before grapes and lumber.

Miles and miles of tunnels were excavated below the town's surface, with millions of tons of tailings accumulating around its perimeter. These underground veins intersected, and miners picked at their neighbors' ore pockets or poked drain holes to get rid of seepage into their neighbors' tunnels. Large capital became indispensable to insure efficient exploitation of the quartz mines, and large crews of men were needed to sink shafts and dig, haul, and crush quartz to extract the gold. The myriad of small claims around town progressively consolidated into three major mine areas: the Empire, the North Star, and the Idaho-Maryland.

Mining improved with the arrival of tin and copper miners from Cornwall. The world's greatest hardrock miners brought to this dangerous occupation their invaluable skills and equipment, their superstitions, and the exclusion of all men deemed potentially unreliable like the Chinese, Native Americans, and African Americans. Many of those who worked 10-hour days, six days a week in the underground maze also practiced "high-grading," smuggling hundreds of thousands of dollars in gold each year, a counterbalance to the inequity of earnings between themselves and the affluent entrepreneurs. This steady stream from Cornwall reinforced an already substantial foreign-born population. The 1870 census counted 10,479 native-born citizens and 8,655 foreigners, among them 2,600 Chinese and only 9 Native Americans.

The completion of the transcontinental railroad spawned a large network of local narrow gauge railroads, and nowhere was this more needed than in Grass Valley where they linked the rich mining district with the Central Pacific's trans-continental trains in Colfax. Historian Jim Morley estimated that the narrow gauge carried more gold, some $300 million worth, than any other short line in California during its 66 years of operation.

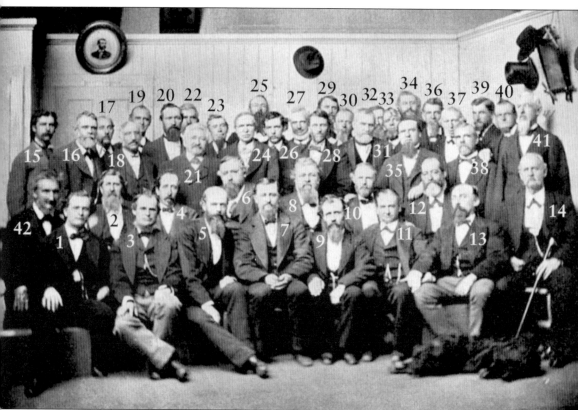

PROMINENT BUSINESSMEN OF THE 1870S. This meeting at the Holbrooke gathered some of the powerful men of Grass Valley and Nevada City. Pictured are 1. Edward Coleman, 2. E. W. Roberts, 3. John Coleman, 4. John Johnston, 5. Reuben Leach, 6. Rufus Shoemaker, 7. Sam Granger, 8. Wm. Watt, 9. Thomas Othet, 10. Dr. S. M. Harris, 11. A. B. Dibble, 12. Dr. McCormick, 13. Peter Johnston, 14. D. P. Holbrooke (holding a cane), 15. Al. Mulloy, 16. J. E. Holden, 17. C. C. Townsend, 18. H. Silvester, 19. J. A. Bryant, 20. David Watt, 21. S. Novitzky, 22. Denis Meagher, 23. J. M. Lakenan, 24. Thos. Fielding, 25. Henry Scadden, 26. Con. Taylor, 27. J. L. Smith, 28. George. W. Hill, 29. Col. R. Clarke, 30. J. P. Stone, 31. Judge John I. Sykes, 32. B. Gad, 33. C. W. Stokes, 34. Wm. Byrnes Jr., 35. Geo. Johnson, 36. A. B. Brady, 37. Patr. English, 38. W. K. Spencer, 39. Geo. Wilson, 40. W. C. Pope, 41. J. J. Dorsey, and 42. Dr. E. A. Tompkins. (*History of Nevada County with Illustrations*, published by Thompson and West in 1880, reprinted by David Comstock.)

HEADQUARTERS FOR THE NARROW GAUGE. In the 1870s, stage and wagon rates were so high that citizens clamored for a rail connection. It materialized in 1875 when civil engineer John Flint Kidder laid out a 22.5-mile route from Colfax to Nevada City. Workers removed buildings, blew up trees, blasted tunnels, and built bridges and over 5,000 feet of trestles. On January 17, 1876, the engine *Grass Valley* steamed into Grass Valley's brand-new station for the first time. Machine shops, yard, offices, and the new locomotive house were all located at the top of the retaining wall on Bennett between Bank and Kidder Streets. At Colfax, three trains a day connected those of the Central Pacific. (Above Sadie Angiolini Trust; below California State Library.)

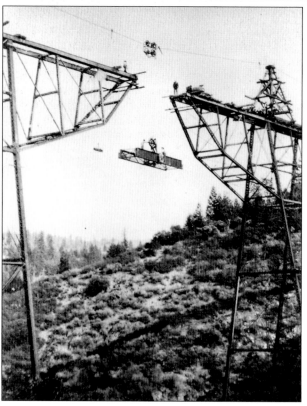

THE CIRCUS TRAIN WRECK. The railroad provided trains for special events like May picnics or to meet presidential trains at Colfax like Teddy Roosevelt's in 1903. It also brought carloads of exotic animals for circuses until 1893, when a carload of horses shifted to the side of their car, pulling over the locomotives and adjacent freight cars containing lions and bears cages. Only dog and pony shows continued to use the railroad afterward. Upon John Kidder's death in 1901, his widow, Sarah, succeeded him as president of the little railroad, the only woman in the United States to serve in that capacity between 1901 and 1913. The line's most spectacular structure was built during her tenure: a Howe Truss Bridge, 160 feet long and 95 feet above the Bear River, shown below as the last section was put in place in 1908. (Jim Johnson.)

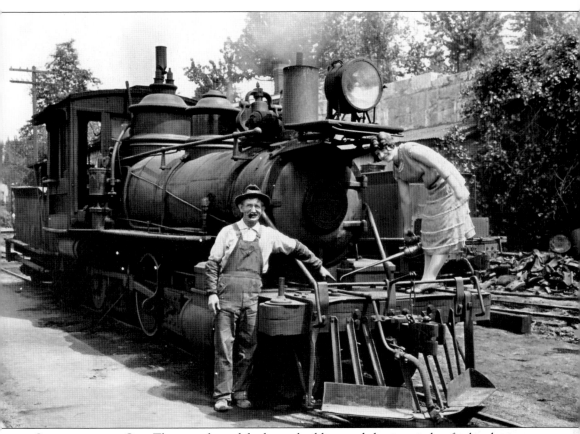

CONVERTED TO OIL. The use of wood for home building and shoring timber for local mines had so decimated trees by 1906 that the Nevada County Narrow Gauge Railroad (NCNGRR) began to convert the locomotive boilers from wood to oil burners. Oil was a new and emerging energy source in ample supply and cheaper to purchase. By 1908, all the locomotives had been converted. Freight agent Tom Kennedy and bookkeeper Sadie Geronimi Angiolini are shown here oiling No. 5's engine truck pin at Grass Valley. (Sadie Angiolini Trust.)

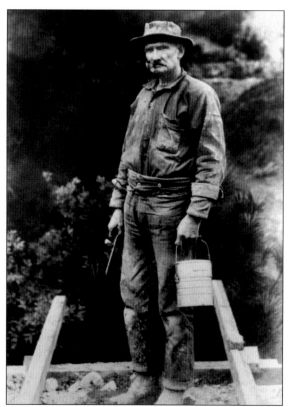

"COUSIN JACKS." Cornishmen who emigrated to work in Grass Valley's hardrock mines were nicknamed Cousin Jacks, since they seemed to have an endless supply of relatives and "cousins" to recommend for jobs. These hardy, knowledgeable miners typically went to work with their "letters from home," round lunch pails that held a peppery meat pie called a pasty in the top section and hot tea in the bottom to keep it warm. Their candlestick holders could be stuck in rock and doubled as redoubtable weapons. One of their most valuable contributions was the "Cornish pump," a heavy iron and wood mechanical water device that meandered deep into the mines to pump out the ground water that constantly accumulated in the shafts. Author Shirley Ewart chronicled many Grass Valley's Cornish families, including the Georges and Bennallacks. (*Gold Cities* by Jim Morley and Doris Foley, 1965.)

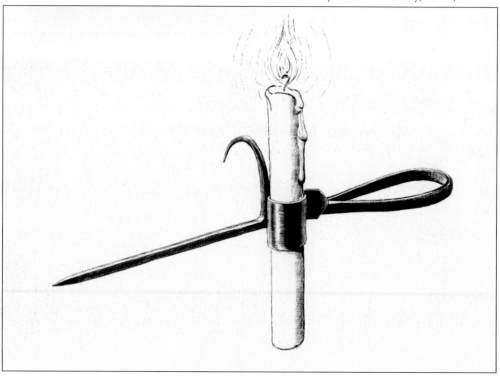

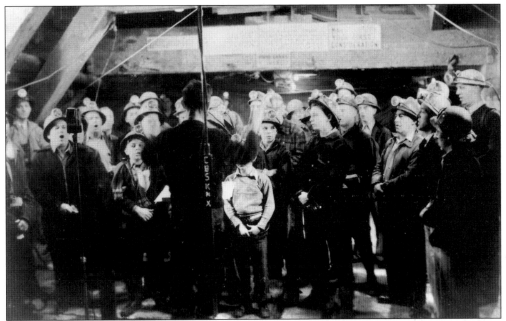

GRASS VALLEY'S CORNISHMEN CELEBRATE. Their Carol Choir was organized in 1890, although songs floated up from the mineshafts long before. The George family is particularly remembered for their dedication to music. Harold Jewel George, born in 1888, was a conductor for the Grass Valley band for 40 years. He taught music at Grass Valley High for 18 years, and his son Harold T. took over the job. In 1940, Harold J. directed the famous Carol Choir during their performance from the 2,000-foot level of the Idaho Maryland Mine, giving the town national attention and starting a tradition that still continues every Christmas today. In addition to the town band and the Methodist Episcopal Church band, a number of other Cornish instrumental groups took turns leading parades. (Above Jim Johnson; below Searls Library.)

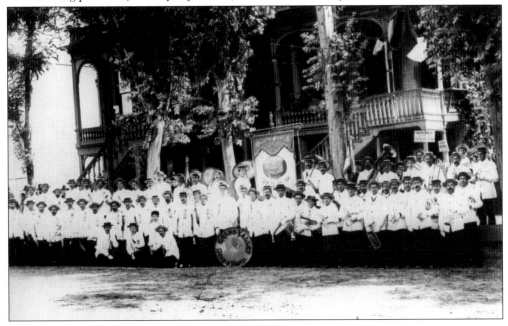

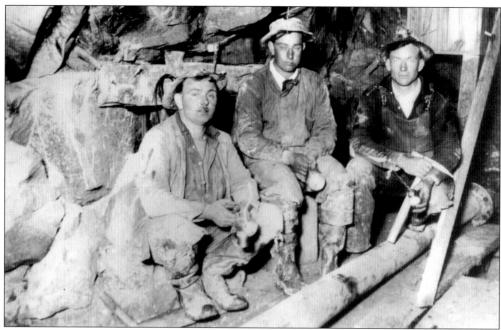

JOHN BLASAUF BENNETT. Named Blasauf for a local Swiss brewer and family friend, John Bennett became an Empire miner at an early age. This c. 1902 photograph shows him at right, resting with fellow miners in one of the rest stations carved inside the main shaft. At age 20, John married Annie Constantine, born in Grass Valley also in 1878 and also of Cornish parents, shown here at the home they built at 328 Marshall Street on a property her parents had homesteaded years earlier. After a mining accident killed one of his friends, Bennett became an ardent spokesman for mining unions. He was blackballed from work in hardrock mines as a result, but he subsequently worked his own Emily Mine. Never admitting to any rich strike, he was always mysteriously able to keep his family quite well. (Jack Bennett.)

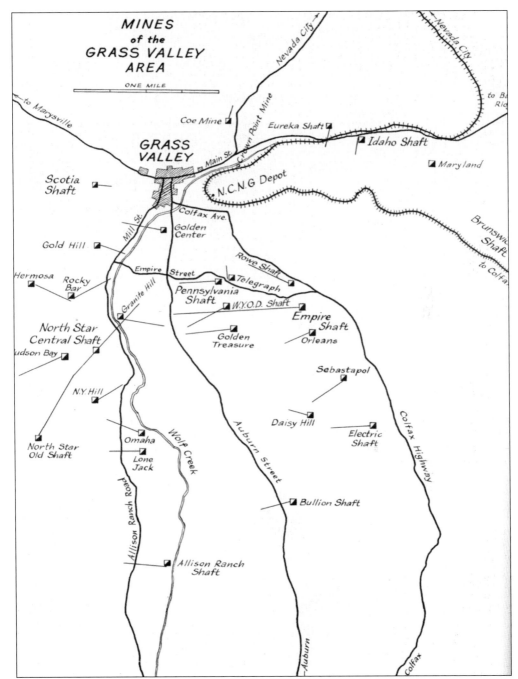

GRASS VALLEY'S LEGENDARY MINES. Grass Valley's underground was perforated by hundreds of miles of mine shafts that extend in every direction. These shafts can be as long as 11,000 feet on the incline and, when measured vertically, can reach 200 feet short of a mile downward and 1,500 feet below sea level. They followed veins that sometimes extended more than 9,000 feet. Historian Jack R. Wagner calculated that more than $440 million worth of gold was taken from Nevada County mines between 1848 and 1965. Some $350 million of it came from Grass Valley mines alone. (Nevada County Narrow Gauge.)

WILLIAM BOURN JR. After Bourn Sr. died in 1874, his 22-year-old son William Bourn Jr. (pictured above), refusing to believe the Empire Mine was worked out, conducted a systematic exploration until he found a new ore vein. By 1884, the Empire was again showing a profit, and it remained the oldest, largest, and richest mining operation in Grass Valley. Much of the Empire's success was due to Bourn's cousin, George W. Starr. Under their management from 1898 to 1928, the Empire was reputed to be the best-managed gold mine in America and the most productive in the state. During its 107 years of hardrock mining, the Empire produced in excess of $960 million, based on the 1974 world market price of gold. It was sold to the Newmont Mining Corporation in 1928 shortly before Bourn's death. (Above Comstock Bonanza Press; below Robert J. Chandler.)

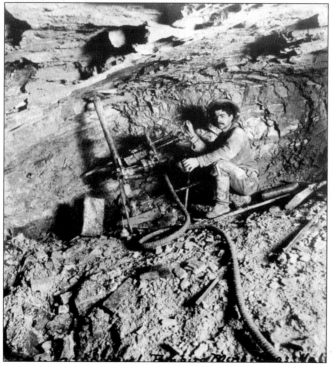

MANSKIPS. Miners were loaded 20 at a time into skips like this one. Hands low, arms tucked in, they dropped at a speed of about 800 feet per minute down the main shaft with only the feeble light of their candlesticks. Seating was cramped, but the ride up or down the shaft was very short. According to Jack Bennett, the men sang Cornish hymns as they went down. (Searls Library.)

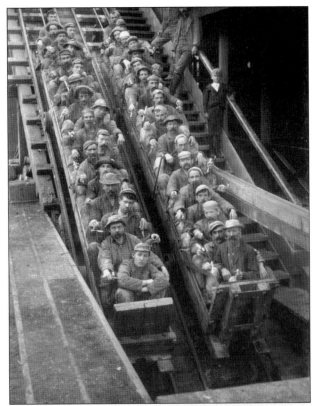

MULES UNDERGROUND. Bourn and Starr brought many improvements to the Empire mine, including mules used underground to pull loaded ore cars from drifts to the main shaft. Up to 44 mules were well cared for and lived in snug underground barns until they became too old to work. Mule keepers were rumored to have smuggled gold in a dead mule's carcass right past the inspector and thereafter retired. (Jim Johnson.)

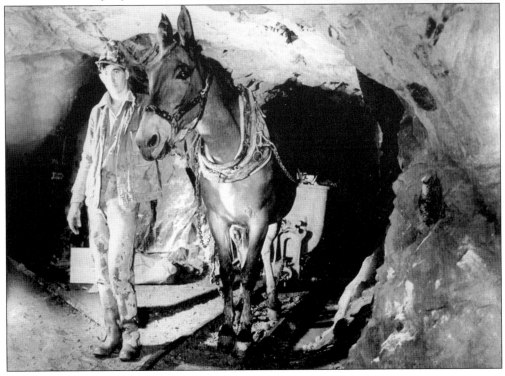

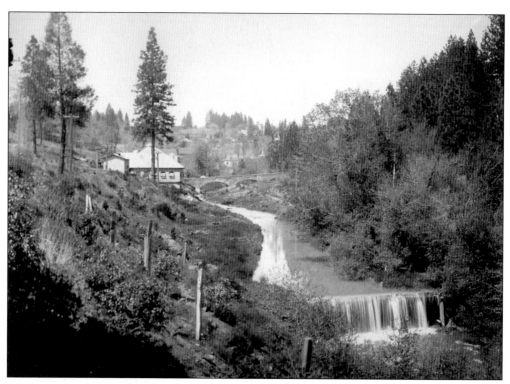

THE NORTH STAR. William Bourn Sr. and partner R. P. Hammond purchased the North Star mine for $16,000 in 1884 when it was considered "played out." They installed five Pelton wheels and switched to water to power their main hoist, stamp mills, air compressor, and Cornish pumps. By 1886, the North Star was again prospering. The partners sold it the next year to skilled engineer James D. Hague for $254,000. (Jim Johnson.)

MARY HALLOCK FOOTE. Two weeks after her marriage, Mary journeyed west with her new husband, Arthur Foote, a mining engineer who first worked at Santa Clara's New Almaden quicksilver mine and then, from the 1880s on, at Grass Valley's North Star Mine. Mary chronicled her impressions of their travels and became one of the best-known women writers and illustrators in the nation. Her insightful reminiscences were used in Wallace Stegner's *Angle of Repose*. (Leonard Berardi.)

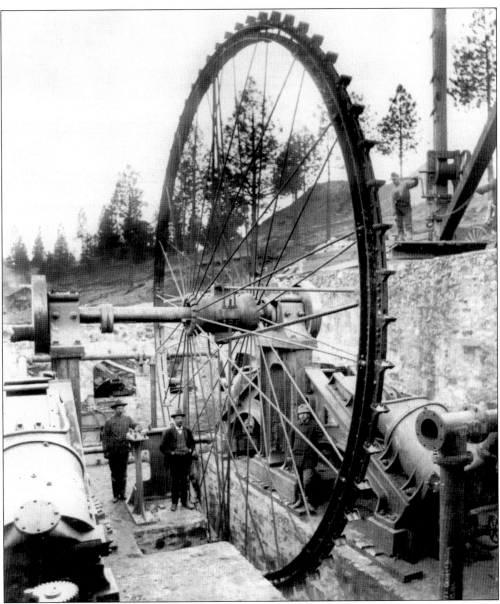

THE PELTON WHEEL. Around the years between 1884 and 1886, mines abandoned steam power due to the extensive destruction of local forests and turned to waterpower, incorporating the use of Pelton wheels. Arthur D. Foote designed the world's tallest, a 32-foot-tall Pelton wheel used to compress air for the North Star Mine's central shaft starting in 1895. Built in San Francisco and transported in sections on the narrow gauge to Grass Valley, it was so large that it had to be unloaded and reloaded at the other end of the You Bet tunnel. The arched stone aqueduct on Wolf Creek, just below the old settlement of Boston Ravine, was built to bring water to Foote's Pelton wheel. Heavy pipe was laid down and covered with masonry to create a pipeline, which carried water from a reservoir many miles away so there would be sufficient pressure. Today's North Star Mining Museum, housed in the mine's 1895 stone powerhouse, is one of the most complete hardrock mining museums in California. It is located next to a beautiful creek side rest area. (Comstock Bonanza Press.)

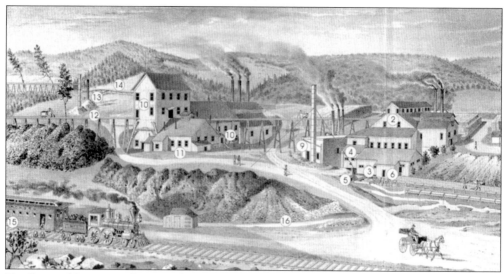

THE IDAHO-MARYLAND SURFACE BUILDINGS. The buildings in the illustration above are identified as follows: 1. office, 2. mill, 3. buddle house, 4. machine shop, 5. drain tunnel, 6. sulphurets house, 9. pump house, 10. hoisting works, 11. blacksmith, 12. waste rock track, 13. airshaft, and 14. water ditch. In 1893, dwindling ore reserves and a dispute with the adjacent Maryland Mine led the Colemans to sell the Idaho to Samuel Dorsey, owner of the Maryland (see page 40). Dorsey closed the mine in 1901 for lack of capital. Mining engineer Errol MacBoyle, hired in 1914 to make a comprehensive study of the mine, became convinced it was still very rich. He gathered capital, consolidated surrounding mines, rebuilt the surface plant, dewatered the shaft, and started operations again. The mine showed progress 10 years later with "tributers," miners who agreed to accept a portion of the profits in exchange for their labor. (Above Comstock Bonanza Press; below Jim Johnson.)

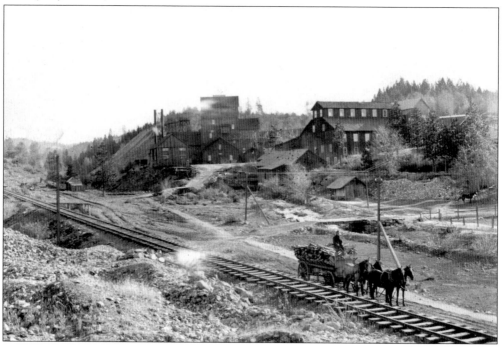

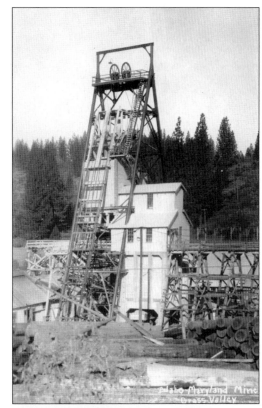

ERROL MACBOYLE. MacBoyle's new improvements, according to historian Jack Clark, included a new 105-foot-high steel headframe above a 30-foot-high semicircular dam to form a large lake for impounding mill tailings, an electric locomotive and a train of ore cars to move the material, a new metallurgical laboratory with an electric furnace, and a new cyanide plant for amalgamation. New ore pockets were found, and the payroll rose to 300 employees in 1933 just as the price of gold rose from $20 to $30. The Idaho Maryland investors reaped a fortune when more and more new ore was found until the enterprise controlled 2,180 acres of land and employed 1,000 men. With his earnings, Boyle built an airfield for his planes and acquired the 452-acre Conti Ranch, which he renamed Loma Rica Rancho, Spanish for "rich earth." (Above Robert J. Chandler; below Comstock Bonanza Press.)

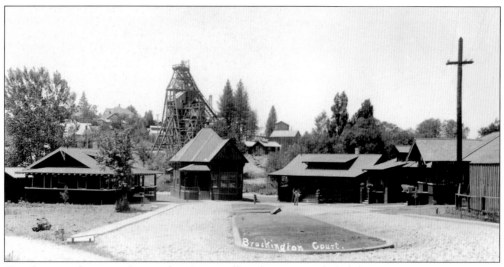

THE GOLDEN CENTER. Centered in Grass Valley, this mine included the Dromedary, Rock Roche, and Peabody mines and mineral rights from the Catholic church and from owners of many lots in, around, and beneath the town: its Church Hill, Garage, Sleep, and Dromedary veins reached under the city's homes, business blocks, churches, and schools. The 1913 photograph above shows the Golden Center headframe rising above the banks of Wolf Creek just behind Brockington Court, where the mine's surface buildings stood. The view below was taken from the headframe. Historian Bob Wyckoff related how one vein was discovered by Studebaker automobile dealer A. B. Snyder while excavating his garage floor to install a gasoline storage tank on Mill Street where Wells Fargo Bank stands today. Many tons of crushed ore later, Snyder decided that selling Studebakers was easier than digging for gold: he sold the mineral rights to Charles Brockington. (Jim Johnson.)

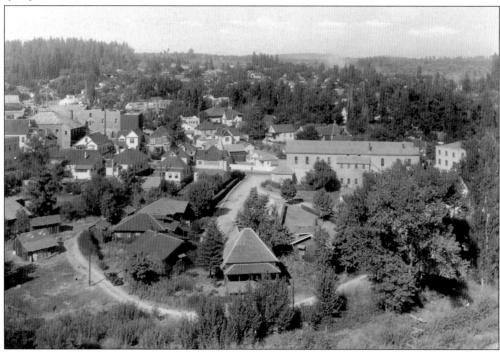

CHARLES A. BROCKINGTON. This native of Michigan came to Grass Valley with his parents at age 10, attended school, and started work at the Empire Mine at age 13. He traveled and worked mines in Alaska and Tombstone, Arizona, before returning to Grass Valley in 1884 and ran the Alpha, Orleans, and W.Y.O.D. mines. On St. Patrick's Day, 1913, he incorporated his own company, christened "the Golden Center Mining Company" by his wife, Lucy O'Donnel Brockington. The couple owned a beautiful home at South Auburn and Neal Street. Today's Safeway store was built on the site of the mine's surface buildings. A piano and clock from their home is exhibited at the Grass Valley Museum together with a table used for signing the 1945 United Nations charter in San Francisco, purchased by their daughter Leta Brockington Shanley. (North Star Mining Museum.)

JOSEPH AND JACOB WEISSBEIN. These natives of Germany came to Grass Valley in 1874 and worked as clerks for their brother-in-law Jacob Heyman. With the $700 capital they had saved from their wages, they soon opened a bank in Delano's old building. To impress their customers, the brothers borrowed wooden spools, wrapped them to look like coins, and placed them in the safe. The bank was to become one of the leading financial institutions in the county. In addition to banking, they bought gold and sold life insurance, real estate (like the Eureka Heights district where a lane used to bear their name), stocks, bonds, and gold mines. Joseph's home was at the corner of School and Neal Streets, Jacob's at the top of the Main Street hill, overlooking the city. (*Pictorial History of Nevada County*, compiled by J. E. Poingdestre, published in 1895 and reprinted in 2000 by David Comstock.)

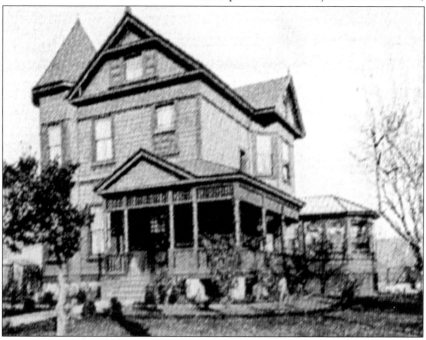

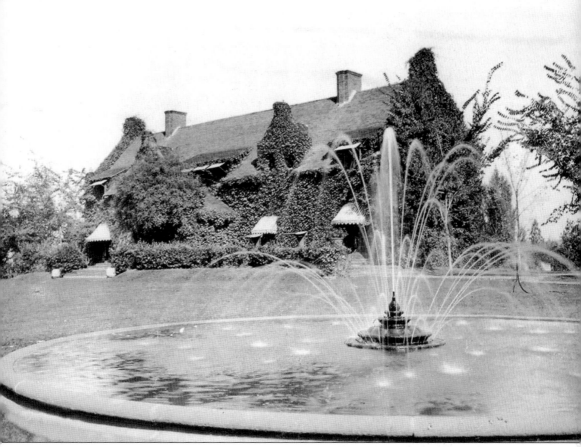

"QUARTZ-CROWNED EMPRESS." New and elegant homes constantly sprang up in the mining town, which turned into a solid, attractive community. Rich from the Empire Mine's profits, the Bourns in particular lived in grand style, traveling between their San Francisco mansion, their 46-room Filoli palace in San Mateo, and their Grass Valley "cottage," an English country-style mansion built close to the mine and designed in 1894 by famed architect William Polk. Up to 10 gardeners, among them George Sing Oyung, tended the 12-acre property, which held 1,500 rosebushes and one of every native tree in California. Springs under the large dance floor kept the footsteps of the ballroom dancers light. A tennis court, bowling alley, billiard room, handball and squash courts, and areas for badminton, croquet, and horseback riding were used for luminaries like Herbert Hoover and the king of Norway. (Jim Johnson.)

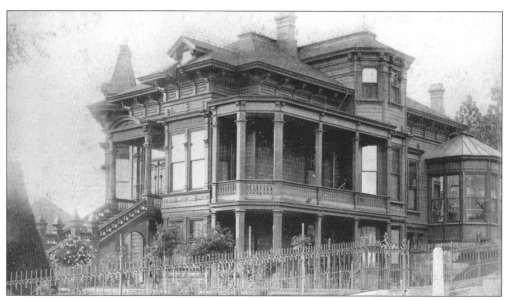

THE KIDDER MANSION. Built in 1883 at the corner of present-day Bennett and Kidder Streets, the three-story, 28-room mansion became Grass Valley's social center even though the railroad shops, yard, and offices were right in front: to Kidder, "the sounds of the little railroad were like music" in historian Gerald Best's words. He and his wife, Sarah, entertained several California governors, Mark Twain, and John L. Sullivan. The mansion was torn down in 1982 on its 99th birthday. Mary Rose Montes Glasson, an accomplished musician and composer who was born in Boston Ravine in 1857, held salons in the mansion that gathered prominent citizens and artists. Her husband, John Glasson, owned the Grass Valley Lighting Company, which furnished the town with light. (Above Jim Johnson; below Comstock Bonanza Press.)

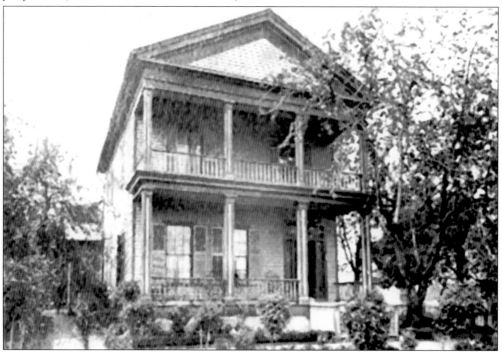

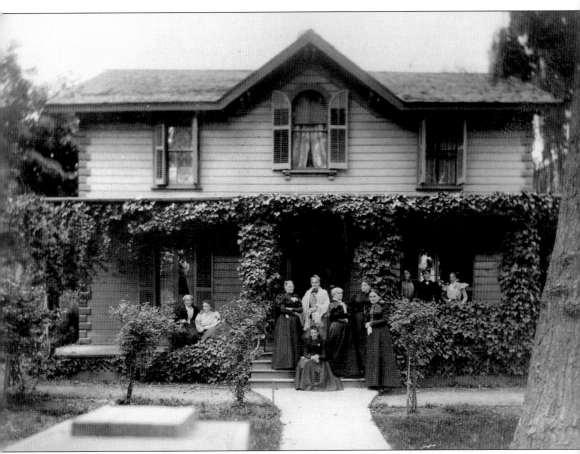

GRASS VALLEY COTTAGES. Less ornate than actual Victorian-style homes, Grass Valley's cottages had larger rooms and wide protective wraparound porches, which provide shade during summer and shelter from rain and snow in winter. The South Church and South School neighborhoods and West Main's Nob Hill are occupied by stately Victorian homes once owned by mine owners, lawyers, and doctors; however, cottages can be found in all corners of town today, from the small miner cottages on Mill Street near Echo Hill and Gold Hill and along Empire and Le Duc Streets, to the medium-sized cottages owned by merchants, masons, and carpenters in the steeper Eureka Heights district or along Race Street. The Lola Montez cottage, with its second story added by the Bosworth family, is typical of the eclectic mix of architectural styles constructed over the last 150 years. (LaVonne Mullin.)

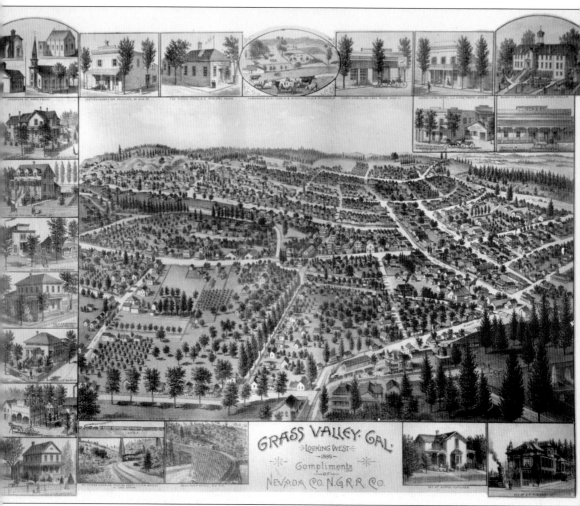

GRASS VALLEY IN 1889. In the 1880s, historians Thompson and West proclaimed that the town, including Boston Ravine, contained "6 hotels, 8 dry goods stores, 10 grocery stores, 5 clothing stores, 3 boot and shoe stores, 3 book and stationery stores, 3 drugstores, 2 furniture stores, 1 general merchandise store, 3 variety stores, 2 millinery stores, 1 tobacco store, 1 hay and grain store, 1 picture frame, paints and oils store, 1 hair store, 2 jewelry stores, 1 hide and tallow store, 1 candy factory, 4 bakeries, 3 merchant tailors, 2 soap factories, 7 markets, 3 livery stables, 4 boot and shoe shops, 5 blacksmith shops, 18 saloons, 4 breweries, 2 lumber yards, 1 planning mill, 2 foundries, 1 stove and tin ware establishment, 1 harness shop, 1 broom factory, 1 soda factory, 1 gas company, 1 water company, 1 amusement hall, 1 bank and broking house, 6 attorneys, 8 physicians, 1 dentist, 2 newspapers, 2 photographers, gunsmiths, carpenters, masons and other mechanics and tradesmen, 7 churches, 1 orphan asylum, 9 school houses and a population of over 7,000." (City of Grass Valley.)

Five

AFFLUENT
PIONEER TOWN

Over time, gold veins petered out and new extracting techniques appeared, but at the dawn of the 20th century, Grass Valley was still producing most of the gold in Nevada County. The Empire, North Star, and Idaho Maryland mines were among the deepest, most productive hardrock mines in the world. As they continued to prosper, Grass Valley became the wealthier of the "Twin Cities" and largest town in the Northern mines. Talented entrepreneurs capitalized on the booming industry to create large and successful businesses. By 1900, 15 out of 22 of its successive presidents of the board of trustees, as Grass Valley mayors were called, had been downtown business owners.

By March 1893, the town formally incorporated, and the city charter was adopted. The images of this thriving town captured by pioneer photographers give visual resonance to an 1895 business directory enumeration. Compared to 1889 (see page 72), citizens seemed more concerned with fashion: there were now 10 barbers at work and twice as many clothing stores, bootmakers, milliners, and jewelers. Two new hotels and several restaurants had opened their doors. Although the town had lost a bakery, it had gained two candy stores, two newspapers, two tobacco shops, a piano and organ store, and a sewing machine store. There was also a new furniture store (these stores often sold coffins and the proprietors doubled as undertakers). The photographs conveyed what the written description could not—the sense of outdoors and fun that prevailed in Grass Valley, from sledding down Main Street in winter to downtown water fights on hot summer days.

Still retaining its original fertility, Grass Valley was described by J. E. Poingdestre in 1895 as a city with "handsome and palatial residences, surrounded by beautiful and well-kept lawns, neat cottages enclosed by well-cultivated gardens, large and imposing church edifices and schoolhouses, broad and well-laid streets, containing large and substantial business blocks, intelligent and cultured citizens." A hodge-podge of building styles reflected the town's varied cultural heritage as well as practicality: covered porches fended off hot summer sun or heavy snowfalls.

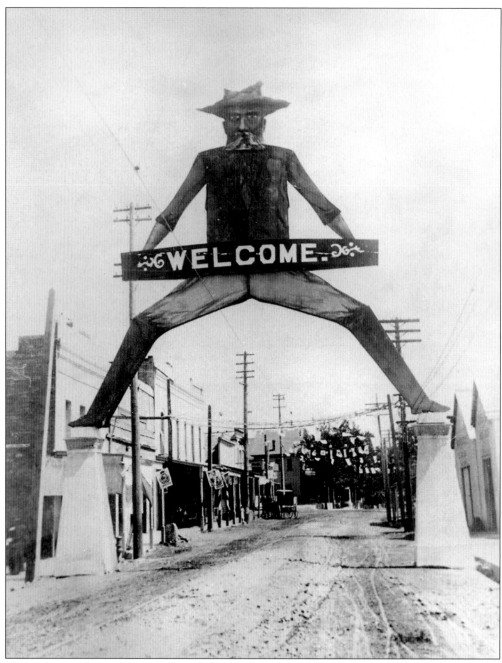

WELCOME TO GRASS VALLEY. This slightly hokey sign at the entrance of Main Street *c.* 1900 is a reminder that the days of the gold rush were not far behind. Grass Valley's population was still composed of hardy pioneers and miners who erected these two signs at the entrance to Mill and Main Streets to celebrate California's 50th anniversary. Trolley tracks and electrical wires are visible on this view at the corner of Main and Auburn Streets, with today's city hall on the right. (Jim Johnson.)

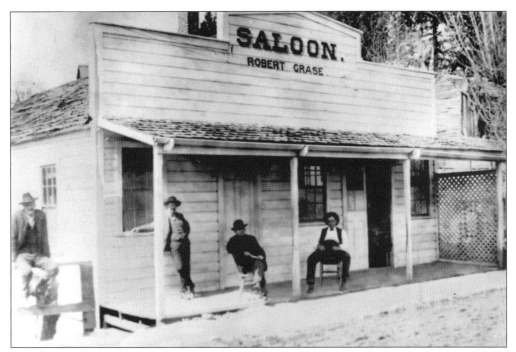

OLD WEST FLAVOR. Bob Crase, seated at right, operated this saloon at Boston Ravine *c.* 1890s. His companions and frequent customers are, from left to right, Joe B eard, "Butz" Riley, and Bob "Black" Bendorf. (Jim Johnson.)

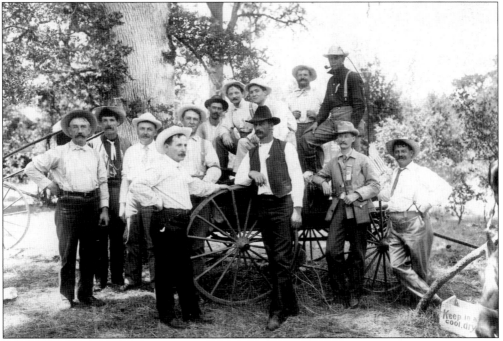

"DOVE STEWS," C. 1904. At the dawn of the century, Grass Valley's Sportsmen's Club sponsored "Dove Stews," all-day events that included breakfast and lunch, card games, and trap shooting. The stew was prepared for dinner. (Grass Valley Museum.)

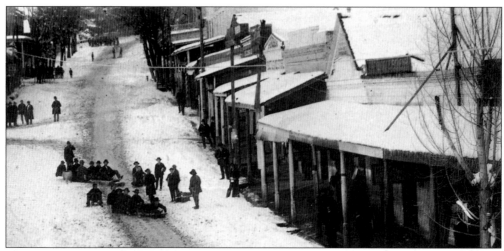

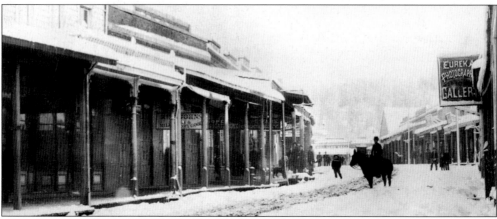

WINTER SNOW, 1890. On snowy days, residents closed off the Main Street hill to Auburn Street and enjoyed sliding down on sleds and toboggans (above, top). In the view of Mill Street looking north (center image), a "Eureka Photographic Gallery" sign is quite visible on the right side of the image. The business was run by Willis Ashmun, brother to Charles E. Clinch and an artist and photographer since at least 1889 (see page 83). (Above and center Jim Johnson; left Carl Mautz.)

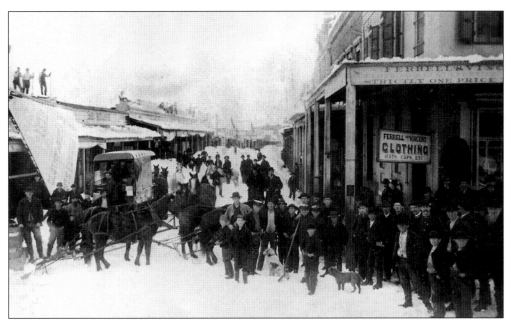

THE WINTER OF 1889–1890. As historian Juanita Brown related in her lively style, that memorable winter brought in two devilish snowstorms: wet, heavy snow crushed houses, caved in roofs, pushed over barns, toppled buildings, knocked down trees, blocked roads and railroads, and isolated settlements for weeks. By the end of the storms, the seasonal snowfall was estimated at 20 feet. In the photograph above, the men on the left were hired to sweep snow off the buildings, but they swept it all onto the next-door building's roof, which collapsed and had to be replaced. The building on the right, home to Ferrell's clothing store and later Eddie Kan Tinloys' "Unique Clothing Store," is the city's earliest brick structure, built in 1854 by the Adams Express and Stage Company at 201 West Main. (Jim Johnson.)

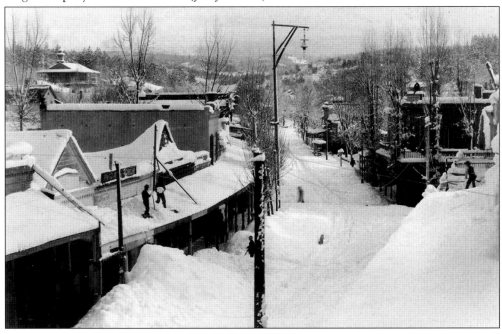

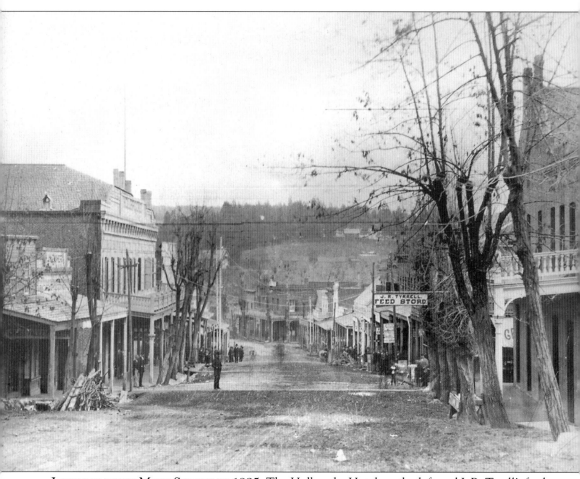

LOOKING DOWN MAIN STREET IN 1895. The Holbrooke Hotel on the left and J. R. Tyrell's feed store on the right help date this photograph. Main Street was still a major artery between Rough and Ready and Nevada City, but it was turning into a busy commercial artery as well. There were no more planks on the road, but electrical wires were already strung across the street. Cemetery Hill is clearly visible in the back. (Jim Johnson.)

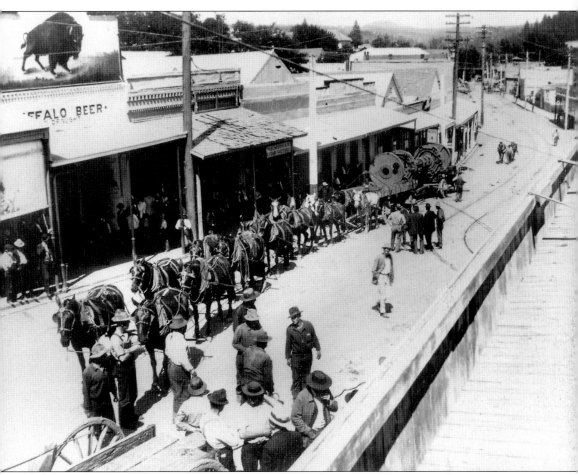

AN IMPORTANT THOROUGHFARE. Grass Valley was still at the intersection of important thoroughfares used by coaches, logging wagons, or this 16-horse team hauling a heavy load of mining equipment up West Main Street from the Grass Valley railroad depot in the 1920s. Streetcar tracks are visible on the right. The Buffalo Saloon was operated in the early 1900s by Joerschke and Sons. The original poster is in collector Ron Sturgil's collection. (Jim Johnson.)

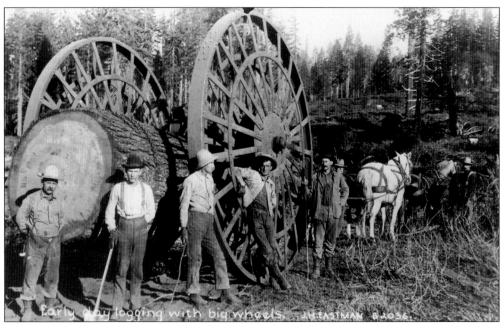

LOGGING WAS BIG BUSINESS. Timber was in high demand for the mineshafts, for the pumps as well as for building homes, and for heat. The enormous wheels in the Eastman photograph above allowed loggers to move old-growth timber to the lumber mills. The 1915 photograph below shows smaller timber being pulled through town by an ox-drawn team. (Above Jim Johnson; below Searls Library.)

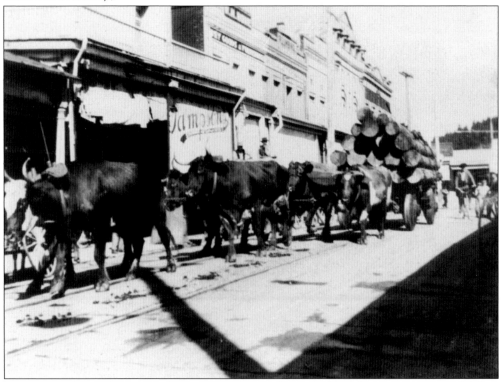

JAMES LEWIS FOWLER. This Massachusetts native was in his 20s when he came to California by way of the Isthmus of Panama. He married Emily Weaver in 1862, and they moved to Nevada County in 1865. Having grown up on a farm, Fowler chose not to mine but rather to homestead land and engage in the logging and teaming business. He eventually acquired 160 acres of land, several sawmills, and two lumberyards, one remaining across the street from today's post office until 1976. James and Emily had six children. In 1900, they built a yellow Victorian in the Hills Flat area for their retirement, which still stands today at 568 East Main Street. A 14-acre sawmill at Glenbrook eventually became the Fowler Center. "Steam donkeys," such as this one below, were used to pull the huge timber onto big wheels or carts. (Charles Fowler.)

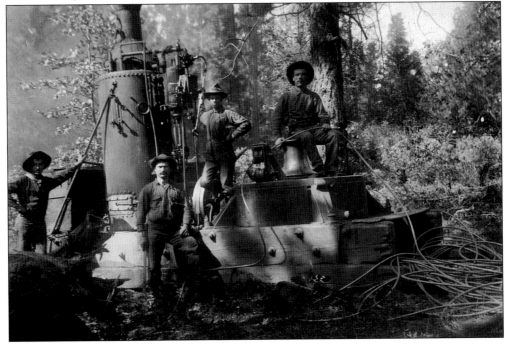

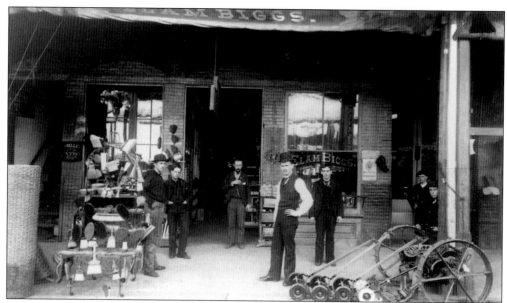

ELAM BIGGS. Biggs turned a store at 114 Mill Street bought in 1890 into one of the West Coast's largest retail providers of "hardware, iron, steel, coal, cutlery, doors, windows, blinds, agricultural implements, mill and mining supplies, paints, oils, varnishes, stoves and ranges, tin, copper and sheet iron ware." His cousin Samuel T. Jones renamed it the "Grass Valley Hardware," and it was operated by four generations of Glenn Jones's family until 1989. (Jim Johnson.)

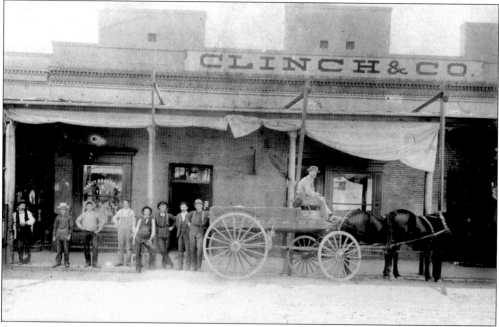

CHARLES E. CLINCH. Born at Lotus, El Dorado County, Clinch came to Grass Valley as a boy and clerked for A. J. Foster for 10 years before founding the Clinch and Company mercantile store at 115 Mill Street with William Bourn in 1883. The business was incorporated as the Clinch Mercantile Company in 1903 after Bourne left. Clinch served as fire chief and as mayor in the 1890s and 1900s. (Jim Johnson.)

A. J. FOSTER'S WALLPAPER STORE. Wallpaper was an all-important supply at the beginning of the century when Victorian-style interiors used sophisticated patterns as wall covering. Charles E. Clinch's store was next door to Foster's. (Jim Johnson.)

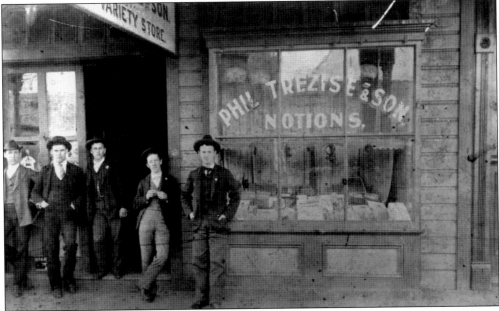

PHIL TREZISE'S VARIETY STORE. Father and son sold notions, which included books and note cards, stationary, and small gift items like candles and candy. Their store was at 112 West Main in the city's second oldest building. It is today Williams' Stationary. (Wells Fargo.)

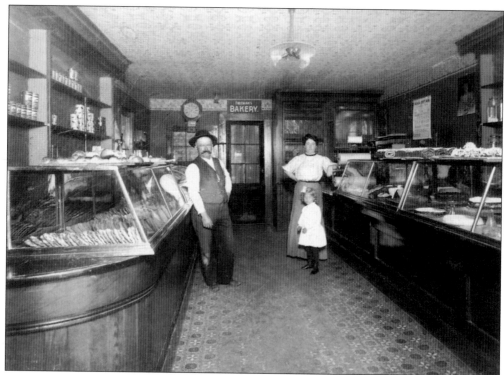

FREEMAN'S BAKERY. One of three bakeries in town, Freeman's operated at the same location at 304 West Main, two doors north of the Holbrooke Hotel, for 52 years. Eli Freeman was the original owner. His nephew William bought the business in 1893 and carried on for 29 years until his retirement in 1922. Their ads proclaimed their high standards: "We use the best materials and never skimp on quantity." (Jim Johnson.)

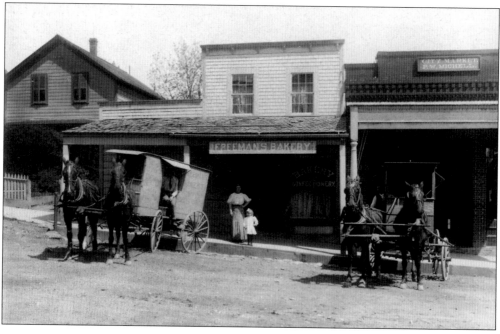

BARTEL JOHNSON. Johnson operated a furniture-and-bedding store at 96 Main Street (now No. 104) from the 1870s until the turn of the century. He used a trade card to promote his business, a very popular and powerful advertising tool that blossomed between 1870 and 1900 when chromolithography was a novelty. Customers collected and pasted these images in large, ornate scrapbooks, which are today prized collectors' items. (Author's collection.)

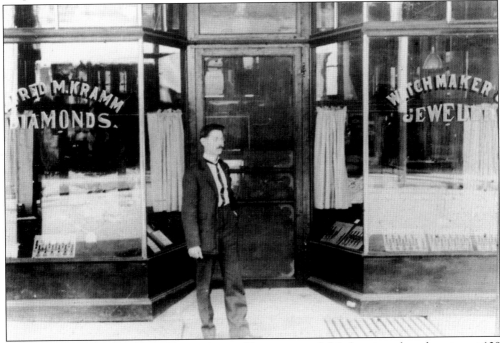

ALFRED KRAMM. In a wise enterprise change, Kramm turned this favorite saloon location at 108 Mill Street into a jewelry store in the 1890s, selling diamonds, jewelry, and watches. It remained a jewelry store until 1997. (Jim Johnson.)

CHINA STREET. Grass Valley's Chinatown reached its height between 1868 and 1878, when it contained numerous stores, cafes, barbershops, teahouses, and restaurants. Local resident Alice Tinloy Yun's grandfather and great-grandfather ran the Quong Chong, an employment bureau that doubled as a bank and helped fellow Chinese find jobs and take care of money. It also held "houses of joy," gambling parlors, and opium dens, a favorite target for police raids. An 1897 city ordinance in Nanci Clinch's collection warned that "every person who loiters about that part of the City of Grass Valley known as 'Chinatown' without any apparent business, or who visits any house of ill-fame therein, or loiters in any house therein where any lottery or game of chance is conducted, or opium or intoxicating liquor is sold, is guilty of a misdemeanor." Below is artist Ron Wedlake's rendition of Chinatown, c. 1891. (Above Alice Tinlay Yun; below North Star Mining Museum.)

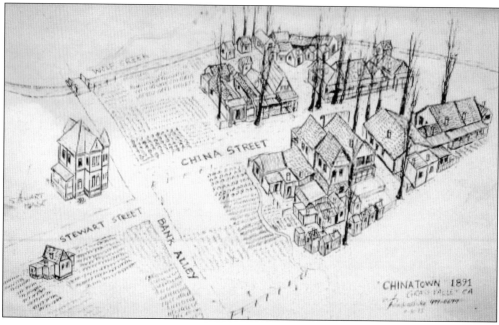

YING HING. Hing was a merchant with the firm of Sun Tong Hing, one of the stores that lined China Street. Storekeepers were respected, trusted, and called upon to arbitrate disputes, convert gold to coins and bank cash, and send money home via San Francisco. Chinatown also provided barbers, letter writers, and herbal doctors. The Chinese were not allowed to own buildings, and rented them from non-Chinese owners. (Searls Library.)

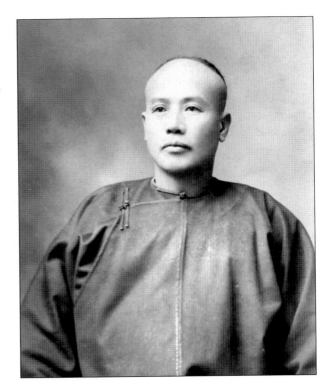

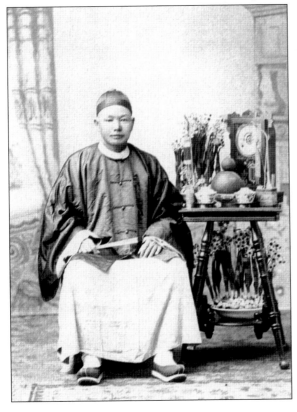

AH GIN. Ah Gin came to California at age 14, worked for the Central Pacific Railroad, and then turned to farming. He became a successful, well-known merchant. Among other enterprises, he grew vegetables on eight acres in Glenbrook and hired peddlers to sell his crops in both Grass Valley and Nevada City. He and his wife had a daughter, Fannie Gin, and an adopted son, Young Son Gin. Grass Valley resident Laura Lee Goudge is Ah Gin's granddaughter. (Wally Hagaman.)

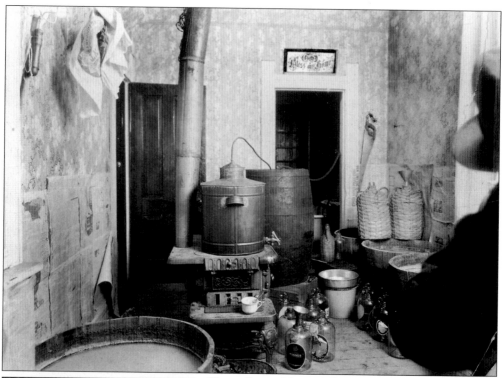

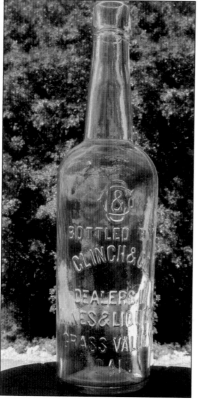

HOME STILL. Home stills existed long before and after Prohibition. Collectors Aaron and Shelley Hill ran across a few during their digging trips. An enormous supply of whiskey bottles was unearthed around Grass Valley by bottle collectors, especially at the time of the opening of the Golden Center freeway. This Clinch and Company whiskey bottle was sold on the premises of the well-known grocery store. (Above Jim Johnson; below Aaron and Shelley Hill.)

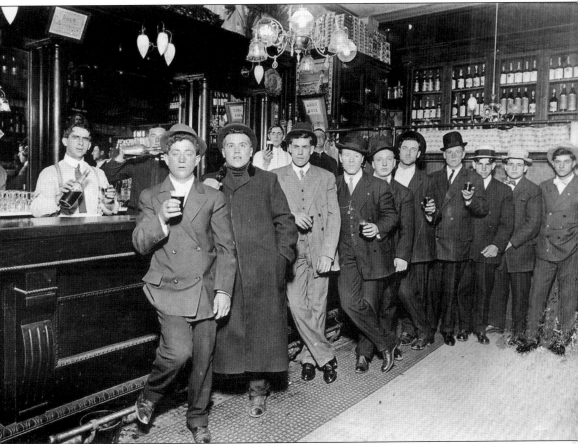

THE "OWL." The Owl, one of the many saloons that flourished in Grass Valley in the 1890s, was named for the miners' often-nocturnal lives since gold mines operated around the clock every day. In 1899, the Grass Valley Union's efforts to close the town's saloons at midnight to prevent drunken brawls were rejected when the majority of citizens signed a petition opposing it. Liquor dealers were then the leading retail business with 44 establishments. (Jim Johnson.)

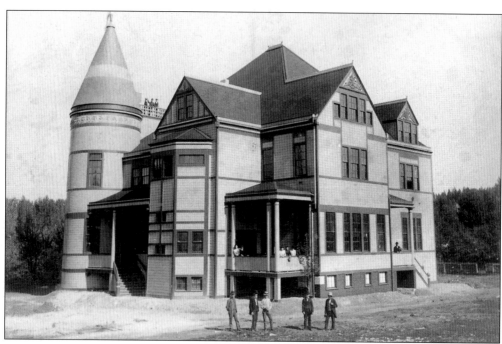

COLUMBUS SCHOOL. Erected in 1892 on South Auburn Street at a cost of $20,000, Columbus School contained 12 rooms, a library, offices, an assembly room, and science labs in the tower. It had electric light by 1896. The 22 mostly local staff members taught all grades from kindergarten to high school. Former student Ed Yun remembered that there were separate stairways for boys and girls, including one very steep direct to the second floor, and that the basement was the preferred location for surreptitious smoking. Renamed Grass Valley High in 1900, Columbus was replaced by Hennessy School during the Depression. Grass Valley High Seniors during the first decade of the 1900s were in charge of *Stray Leaves,* the school's yearbook and monthly review. (Jim Johnson.)

GRASS VALLEY'S "DONATION DAY" TRADITION. In December 1883, Carolyn Mead Hansen, a semi-invalid who watched children going to school from her window, conceived of Donation Day, which became one of Grass Valley's lasting and unique traditions. She suggested that every school child, on the last day of school before Christmas, bring to the school "a potato and a stick of stove wood." School trustees picked up on the idea, someone suggested a parade, and someone else a band. Businessmen joined the parade, as well as employees, carrying blankets, sacks of flour, canned goods, vegetables, meats, poultry, and strings of sausages. Donation Day's festive, genuine goodwill spirit survived into the 21st century. On this photograph, participants are gathering to form an early Donation Day parade on School Street, near Neal Street, in front of what was Grass Valley's first "Advanced Grammar" (High) School, only a few steps away from the house of Carolyn Hansen, who inspired the event. This took place before 1892, when Columbus School was built. (Jim Johnson.)

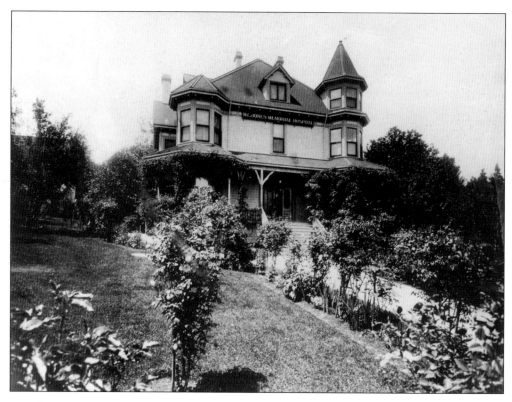

W. C. JONES MEMORIAL HOSPITAL. In 1907, Dr. John Jones and his brother Carl converted an old 1867 home at 328 South Church Street, which had been remodeled in 1895 to Queen Anne style, into a hospital named after their father, Dr. W. C. Jones, a local country doctor from 1874 to 1900. The hospital opened early in 1907 and acquired the county's first X-ray machine. The Grass Valley Museum dedicated an entire room to the hospital's memorabilia. In the photograph below, employees of the Downey Clinch Department Store are wearing masks during the 1918 Spanish influenza epidemic, which struck Grass Valley like the rest of the world. (Above Jim Johnson; below *Nevada County Memories*, published by the *Union* in 2001.)

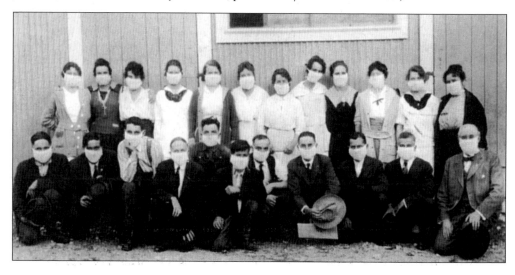

BABY BOOM. In the early 1930s, a record eight babies were born in a 24-hour period at Jones Hospital. There are only seven in this picture; the other family went home fearing that the babies might get mixed up. The fourth baby from the left was Cece Gallino, and the second nurse from the left is head nurse O'Connor. The hospital served as a community medical center until 1968 and was then returned to its original function as a private residence and bed and breakfast. At the other extreme, in the image below, members of a local club that began as the Half Century Club, which met regularly, look as though they might be nearing the century mark.

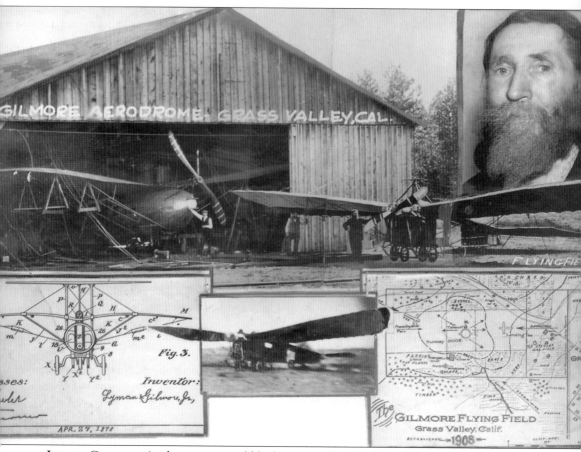

LYMAN GILMORE. As the story was told by historians Jim Morley and Doris Foley, while others burrowed for gold, Lyman Gilmore studied the flight of birds and dreamed of achieving the first powered flight. There is evidence that he built and flew his own "powered glider" in 1902, but the announcement of the Wright brothers' success in 1903 put an end to this dream. Known locally as a strange recluse typically wearing a long coat, Lyman had, like his brother, vowed to not cut his hair until William Jennings Bryan became president. He wore shoulder-length locks until he died at age 74 in 1951. He opened a personal airfield on his 50-acre property in 1910. His wooden hangar, filled with curious machines like the models on this photograph where wires held up bat-like wings, was opened to the public during flying exhibitions he staged there after World War I. Famous aviators were invited to perform, among them Anthony H. G. Fokker, the "Flying Dutchman." Lyman Gilmore School was built on the site. (Jim Johnson.)

Six

TURNING THE CENTURY

Grass Valley always kept up with the times. At the dawn of the 20th century, it had electricity, easy train connections, and a spanking new streetcar service. Its first steam-powered automobile cruised Race Street in October 1901, soon followed by factory-produced ones. Garages appeared, as did competition for roadways between streetcars, horse-drawn conveyances, and the new "horseless carriage" fed with fuel purchased at the hardware store.

Life had until then moved at a slow pace, which historian Bob Wyckoff aptly captured: "Entertainment usually meant taking the family to the silent movies until they learned to talk in 1927; radio was just beginning to sputter its way into our living-rooms, and television was still down the road; our towns were mostly self-sufficient for goods and services; the corner grocery store delivered and a trip to Sacramento was an adventure!"

The new century changed all that, as Grass Valley was propelled into new lifestyles in great part due to the advent of the automobile. The outlying areas became more easily accessible, the town grew out, and new fairgrounds were established at Glenbrook, where Lake Olympia and its nearby motorized race track created new and exciting entertainment. Transformation was not restricted to new technology but included architecture as well, with construction of a new public library, the ceramic-faced Union building, and the Rector brothers' glass-domed masterpiece used as a bank for decades.

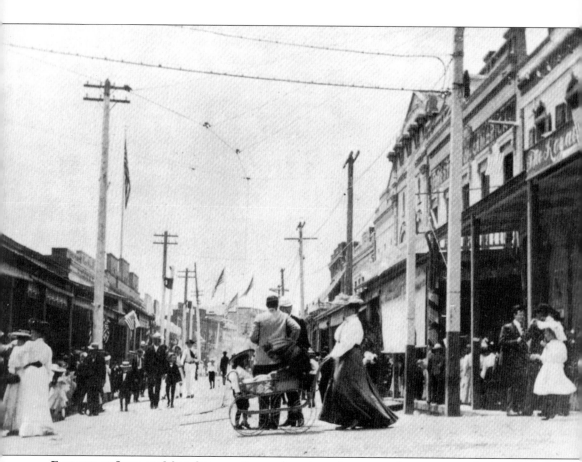

FOURTH OF JULY ON MILL STREET. Postcards such as these started to appear at the beginning of the century when printing techniques allowed photographers to mass-produce their images. Jervie Henry Eastman in particular roamed Northern California from the 1890s to 1960, capturing views like this Fourth of July scene on Mill Street, seen from Main Street. Tracks and overhead trolley wires reveal the advent of electricity and the new presence of the beloved tramway. Eastman specialized in printing, developing, and distributing postcards, and in 1907, he created a machine that increased his production to 200 postcards per hour. The U.C. Davis Library holds a considerable collection of his work (see page 116). (Jim Johnson.)

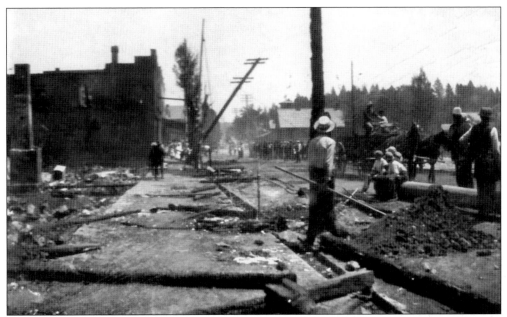

THE NEVADA COUNTY TRACTION COMPANY. A crew of some 200 men labored all summer to install rails for the new streetcar after Mayor Charles Clinch broke ground for the first tie at the Grass Valley city limits on June 5, 1901. Regular service between Nevada City and Grass Valley's Boston Ravine began in the fall. According to historian Gerald Best, the heavy 80-pound rails were set to standard railroad gauge. The 28-ton cars could carry 48 passenger cars each, 36 inside and 12 in the covered, open ends. Trolleys started at both ends of the line at the same time and passed using a spur track at Glenbrook. The Traction Company stock certificates depicted a streetcar completely unlike the ones actually in use. (Above Searls Library; below Leonard Berardi.)

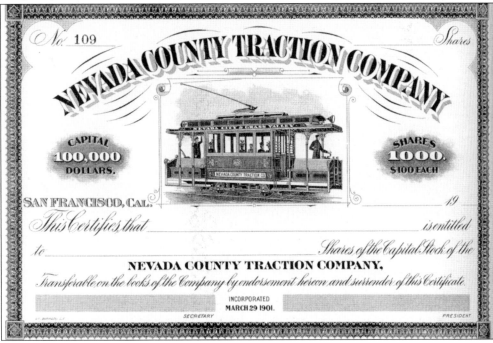

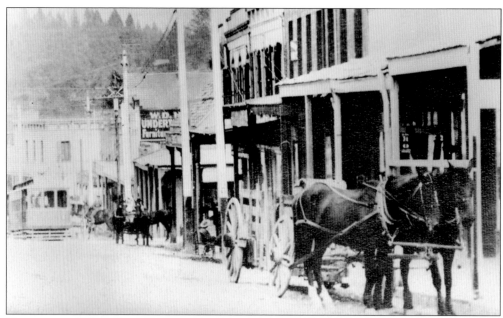

CLIMBING UP MAIN STREET. Streetcars followed Mill Street from Boston Ravine, veering into East Main to Hills Flat and up the old Nevada City Highway to Glenbrook, where car barns and the powerhouse were located. It then crossed on top of the NCNGRR tunnel to Town Talk and ran down Searls Avenue and Sacramento Street to the Broad Street and Pine terminus. Fare was 20¢ between cities and 5¢ in town. (Jim Johnson.)

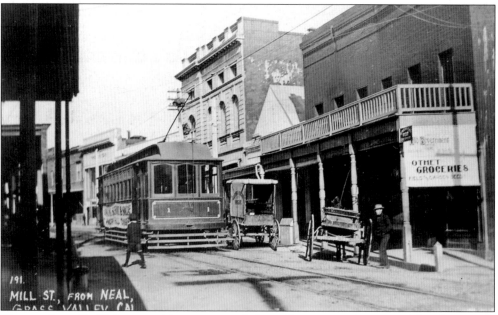

TRAFFIC JAMS. Traffic became tight in town with the trolley cruising the streets. This photograph was taken in front of Thomas Othet's grocery store at 167 Mill Street. Othet, who had come overland from Chicago in 1852, ran a grocery, hay, and grain business at this intersection from 1854 until he finally retired in 1915. It became the site of the Del Oro Theatre in the 1990s (see page 123). (Jim Johnson.)

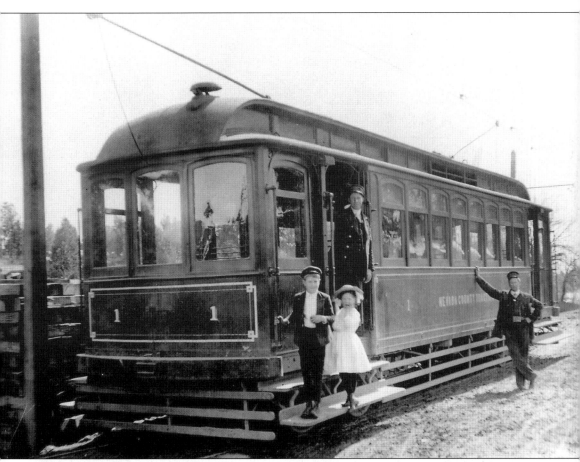

TROLLEY AT GLENBROOK. The Nevada County Traction Company transported riders to Grass Valley and Nevada City and points in between, including the Nevada County Fairgrounds at Glenbrook Park, from 1901 until 1924 when roads were paved and increasing automobile traffic drained its revenue. After an exceptionally heavy snowstorm on January 3, 1924, blocked the line on several points, Superintendent Ed Skewes ordered a one-day shutdown, which was subsequently turned into permanent closure. Three of the cars were burned and the metal salvaged; the fourth was turned into a waiting room for school children. (Jim Johnson.)

JEFFERY'S STEAM AUTOMOBILE. The owner and superintendent of the Gold Blossom mine at Gold Flat, Richard Edgar Jeffery was also a local steam engineer, property owner, and inventor. In 1891, he invented a unique wagon wheel, and in 1901, at his house near the intersection of Race and Clark Streets, he assembled a steam automobile, the first ever built in Nevada County, perhaps the first in California. The car was tested on Race and South Auburn Streets as reported by the *Union* of October 21, 1901. The car was donated to the Nevada County Historical Society in 1947 and restored by Terry Horlick in 1999, and a "Centennial Drive" on October 21, 2001, recreated the first outing of the vehicle a century before. The year 1911 marked the earlier phases of automobile fever in Nevada County when automobile outings started to replace buggy or trolley rides. (Above Searls Library; below Jim Johnson.)

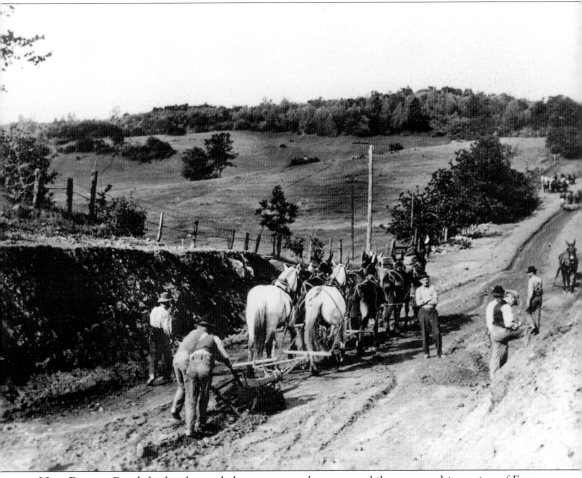

NEW ROADS. Roads had to be graded to accommodate automobiles, as was this section of East Main Street looking west from the Brunswick area in the vicinity of present-day Big O store. The work was done with plows and teams of mules and horses across still-undeveloped hillsides. (Jim Johnson.)

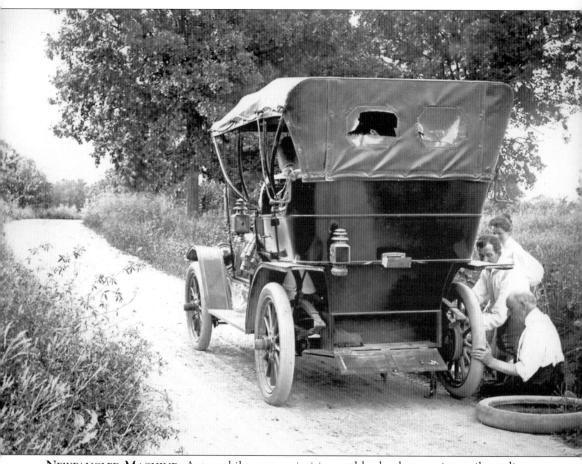

NEWFANGLED MACHINE. Automobiles were primitive and broke down quite easily: radiators overheated, and tires were unreliable, puncturing on a regular basis since they were only covered in cotton. Roads were rough, muddy, narrow, winding, and steep, and gas had to be purchased from local hardware stores. (Jim Johnson.)

LIVERIES TO GARAGES.
Garages started to sprout
everywhere, among them the
Grass Valley Garage on Mill
Street, *c.* 1910. It used to be a
livery stable on the location
of today's Wells Fargo parking
lot. (LaVonne Mullin.)

CHARLES E. CLINCH. This
innovator was among the first
merchants to motorize his
delivery wagons. Clinch's son
Charles Raymond Clinch and
his son-in-law Roy Eugene
Tremoureux helped their
sons Downey C. Clinch and
Roy C. Tremoureux found
Alpha Hardware Company.
(Jim Johnson.)

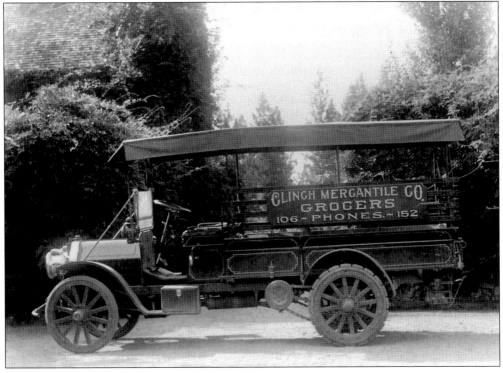

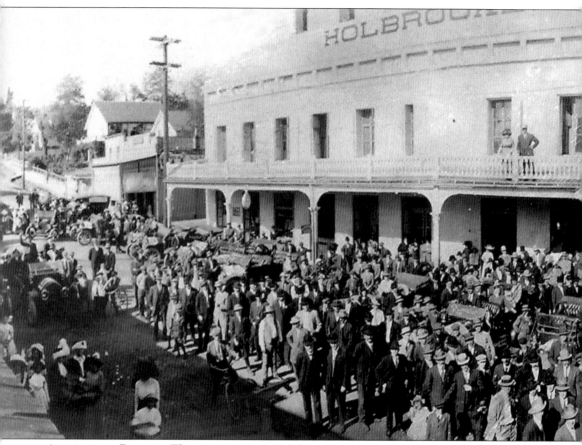

AUTOMOBILE RALLIES. The numerous automobile enthusiasts made motorist rallies one of the popular festivities in Grass Valley, as in the early 1900s photograph above of a crowd gathering

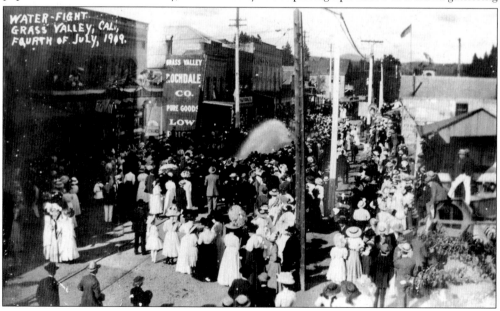

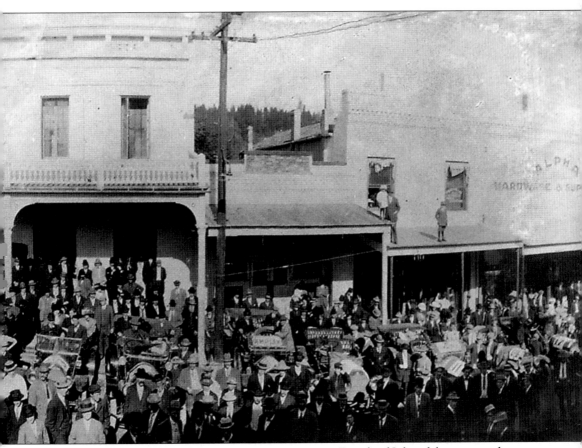

outside the Holbrooke Hotel for a panoramic memento. Fourth of July celebrations with water fights and patriotic parades went on notwithstanding. (Jim Johnson.)

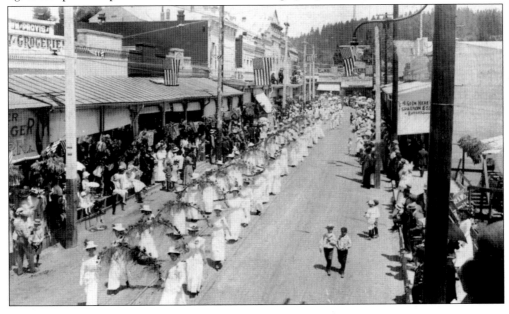

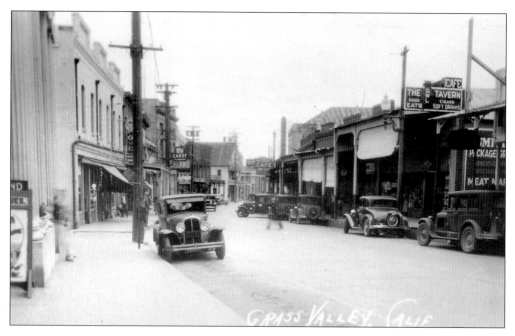

MILL STREET TRANSFORMATIONS. The new "horseless carriages" completely changed the town's appearance, as did the beautiful new public library (below). It was built in 1916 with funds from a Carnegie grant at 207 Mill Street, the site where philosopher Josiah Royce was born in 1855. The library was named for Royce in 2005. (Jim Johnson.)

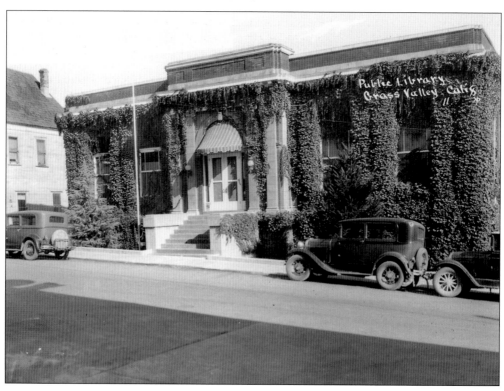

"MODERN" BUILDINGS. The movie industry transformed Mill Street as well. In 1890, Pauline Rickmers Van Hoeter built a three-story stucco and stone auditorium at 162 Mill Street (on the right) known as "Van's Opera House." Dramatic companies and musicians performed on its stage for years. It later became the Strand Theater, where movie shows cost a whopping 10¢. A true pioneer, Pauline had worked as a seamstress at Sutter's Fort and later, according to historian David Comstock, as a secretary to Lola Montez. The Strand is today Hedman's Furniture Store. The impressive glass-domed Nevada County Bank building (on the far left) was built in 1917 at 131 Mill Street by the Rector brothers to house a bank. (Jim Johnson.)

SNOWSTORMS. Storms frequently dumped several feet of snow in Grass Valley in the 1920s and 1930s, turning automobile traffic into a very dangerous operation. It did not seem to deter these two Grass Valley youngsters having fun in front of the new Grass Valley Union building. Erected in 1903 at 151 Mill Street with a ceramic-faced brick façade that was all the architectural rage in the 1900s, the building housed the newspaper for 76 years until it moved to larger quarters at Glenbrook. (Above LaVonne Mullin; below author's collection.)

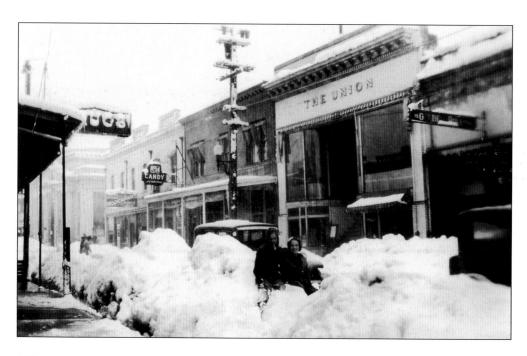

ON THE MOVE. Automobiles made it possible to drive much longer distances. Grass Valley folks started to be on the move. The Western Hotel below, also known as the Traveler's Hotel at the corner of East Main and Washington Streets, across from the street from today's post office, remained an ever-popular place when the automobile transformed travel and the tourist industry was born. A historically accurate reconstruction of it is currently in the planning stages. (Above Jim Johnson; below LaVonne Mullin.)

THE TEMBY HOTEL. The City Hotel stood at 305 West Main Street from the 1850s until the fire of 1862. It was rebuilt as the International Hotel, operated from the 1870s to 1890s as the Cabinet, and later became the Temby Hotel, run by brothers William and Christopher Temby, Cornish wrestlers who also operated one of the finest restaurants in town and for whom a city street was named. (Jim Johnson.)

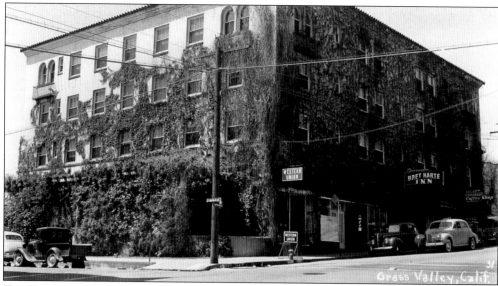

THE BRET HARTE INN. The Temby was razed in 1917 to make way for the Bret Harte, named for the famous author. It became the town's premier hotel, a rival to the Holbrooke. For decades, the world's mining gentry stayed here while conducting business in Grass Valley. It continued as a hotel until it underwent a major remodeling in 1984 when a fifth floor was added and became a retirement inn. (Author's collection.)

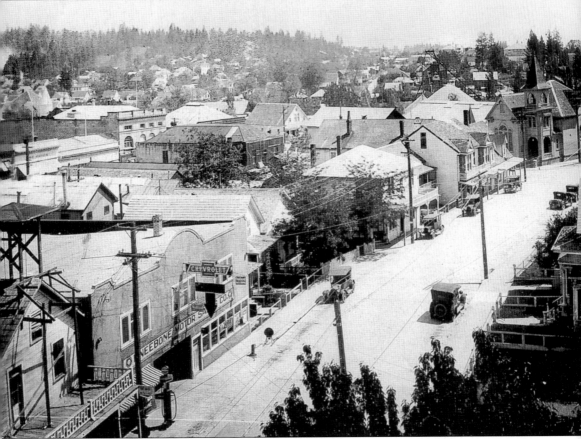

VIEW FROM THE BRET HARTE. This *c.* 1926 view of South Church Street from the Bret Harte Inn gives a glimpse of the turn-of-the-century transformations in town, including overhead wires and trolley cables, horseless carriage traffic, and the now-ubiquitous automobile garages and dealerships like the Chevrolet shop on the bottom left. The Congregational church at far right marks the corner of Neal Street. (*Nevada County Memories,* published by the *Union* in 2001.)

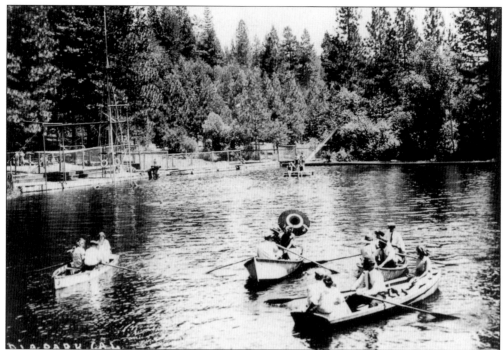

LAKE OLYMPIA. This lake, created in the 1850s when the small Olympia Creek was dammed in the wooded Glenbrook area, became a favorite weekend and holiday spot made readily available to locals who could ride the streetcar or narrow gauge train to the Glenbrook station and walk to the lake carrying a picnic basket. There was a boating facility, a pool with a diving platform, dressing rooms, and a snack concession. An island in the middle of the lake held a popular dance floor, which doubled as a roller skating rink when not in use, according to local historian Ardis Comstock. A dramatic reduction in the flow of the creek led to a progressive drying of the lake. The Glenbrook and Olympia shopping centers were later built near the site. (Above Jim Johnson; below LaVonne Mullin.)

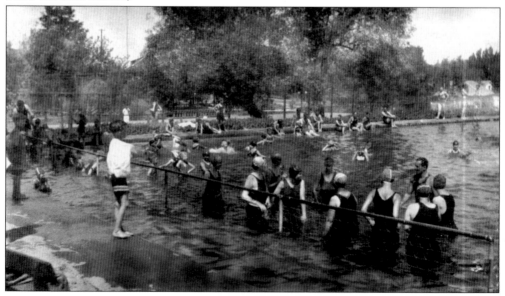

Weekend Fun at Glenbrook. In 1885, the county fairgrounds were moved from Watt Park to Glenbrook next to the Nevada County Narrow Gauge Railroad station. Grass Valley's gold miners, who worked shifts 364 days a year, celebrated their one day off with the annual Miners' Picnic, first held in 1895. This event offered music on the train, and at the picnic were wrestling and boxing matches, tug-of-war between local mines teams, evening dance contests, single- and double-handed drilling contests, and a mining debris shoveling contest against the clock. Races at Glenbrook Park became another highly popular event as the automobile evolved into a more sophisticated machine. This photograph was taken c. 1920, after the tracks for foot and horse races were turned over to car racing. (Right Comstock Bonanza Press; below Jim Johnson.)

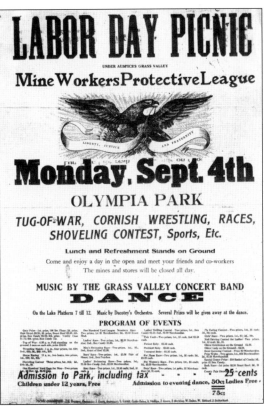

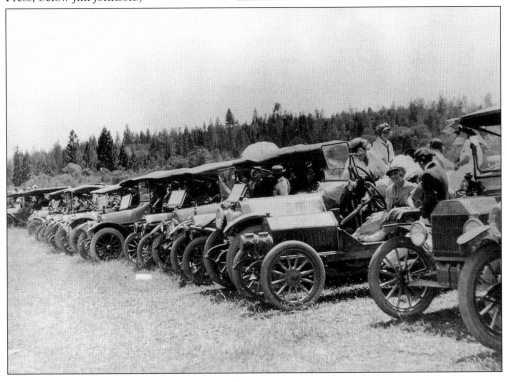

VETERANS MEMORIAL PARK.
The grounds of present Memorial Park near Race Street and the Colfax Highway were purchased at the close of World War I by the Empire Mine Company and presented to the city of Grass Valley in memory of those who served in that war. The Idaho Maryland Mines Company built the community building shown on this photograph at a cost of $2,500. Other individuals, mining companies, and business firms donated equipment and paid for improvements. Memorials dedicated to every war give this popular park a poignant aura. (Above Jim Johnson; left author's collection.)

Seven

PAST AND PRESENT

Change accelerated in Grass Valley from the 1930s to the 1950s. While the Depression saw gold revenues soar, World War II forced the closure of the mines, which brought the end of the narrow gauge railroad. As the town's dependence on a gold economy was shaken to its core, miners enlisted or left Grass Valley for higher-paying jobs in defense industries. Chinatown, now almost empty, was eventually razed, and the bawdy waterfront nearby closed for good. At war's end, the cost of rehabilitating the mines, coupled with inflation costs, left the owners little choice but to "pull the pumps" and allow the huge maze of tunnels and shafts to flood. The "Quartz Queen of the West," like its mines, seemed played out. Its population slipped from 5,701 in 1940 to 4,876 by 1960.

Still, Grass Valley retained an entrepreneurial spirit, slowly diversifying and regaining its position as a retail center. It also managed to keep its history alive by either rebuilding crumbling old homes like Lola Montez's cottage (now the chamber of commerce) or by turning them into museums like the excellent Grass Valley Museum in St. Mary's Convent. The City Council's Historical Commission was created to look after the Downtown Historic District. The town also produced a sense of continuity with its early history by renaming streets and buildings for past pioneers, like Josiah Royce and the Hansen and Tinloy families. The town also preserved century-old traditions like Donation Day, the Cornish Choir, and the Cornish Festival and encouraged revivals like that of the Tsi-Akim Maidu, whose culture preceded the town.

Gone are the days when gold was king. Yet one cannot escape history in Grass Valley. There are remnants of a brilliant past everywhere, from the "hydraulicked" ravines on North Church Street to the pounding holes along Wolf Creek and from the marker on Gold Hill to the monitor at Veterans Memorial Park. The atmosphere of early mining days still lingers in the town's irregular streets and covered porches, in the vivid scars of rock mining along its roads, and in street names that echo the epic search for gold—not just monikers of mighty goldmines and pioneers but ones that evoke the thousands who trekked here, like Miners Trail and Highgrade Lane.

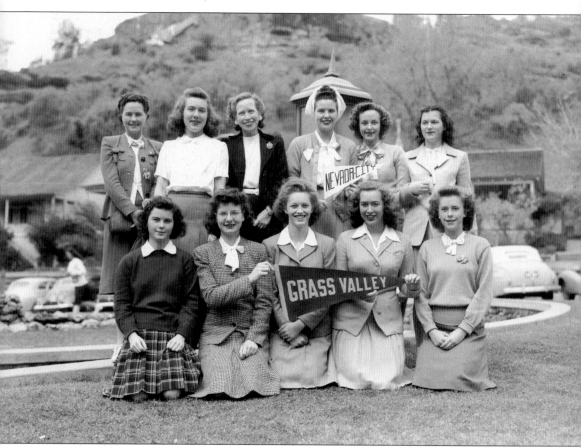

TWIN CITIES GALS. This 1940s Eastman photograph was taken at a conference in Richardson Springs. It gathered students from Nevada City as well as five Grass Valley students identified by Cece Fowler as René de Pauli, Donna Hyatt, Dolores Hamilton, Helen Holmes, and Dolores Pool. At top left is Vera Ingram, a well-liked, popular teacher. Grass Valley and Nevada City were for decades referred to as "Twin Cities" because of their close proximity. This never prevented fierce rivalry in every way possible. (U.C. Davis Library Special Collections.)

THE DEPRESSION. The Depression years did not hit Grass Valley as hard as it did the rest of the nation. The Empire and North Star mine shafts ran into each other underground in 1929, and under the new Newmont Company's management, the two mines were combined and expanded, becoming the largest gold producer in California. Steady jobs were still hard to find. "Camp Grass Valley" became home to the Civilian Conservation Corps, an organization that provided employment for laborers looking for work. (Jim Johnson.)

THE JAMES S. HENNESSY SCHOOL. Built in 1936–1937 in the depths of the Great Depression by the Public Works Administration, this school replaced the three-story Columbus school and was refurbished on its 50th anniversary. Shortly after graduating from Hennessy School, young Midge Gallino found employment as her own school's secretary. She remained in that position for the next 46 years, and the school was eventually renamed for the beloved Midge. (Jim Johnson.)

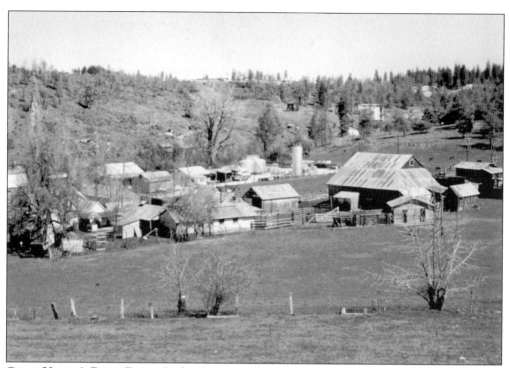

Grass Valley's Dairy Farms. In the 1920s and 1930s, as incomes went down and the pasteurization made drinking milk safe, dairies sprang up everywhere around Grass Valley, and the milk industry boomed. Among them was the Gallino Dairy on Railroad Avenue, run by the family from 1919 until the early 1950s. Between 40 and 50 cows were milked each day, according to Midge Gallino Scotten, and there were two daily milk deliveries, in the morning and afternoon. Milk bottles became increasingly more sophisticated, as did the caps. Today they are collectors' items. (Above Cece Gallino Fowler; both below Midge Gallino Scotten.)

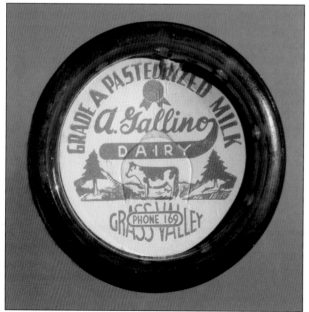

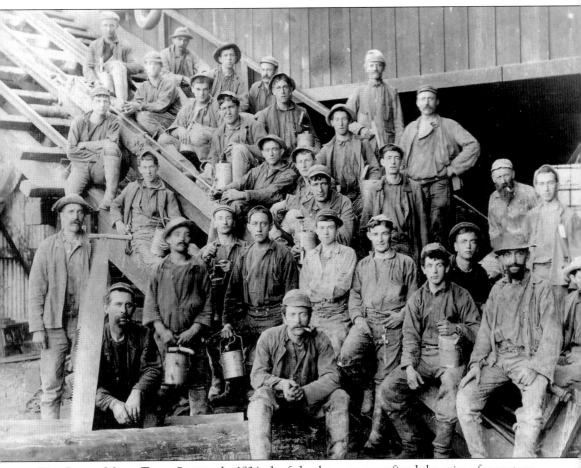

THE STAMP MILLS TURN SILENT. In 1934, the federal government fixed the price of monetary gold at $35 per ounce and became the only legal purchaser, which guaranteed a continuing market for as much as the mines could produce. The 1930s became a boom time unrivaled since the original gold rush. But by 1942, the War Production Board ordered non-essential industries like gold mining stopped for the duration of the war. Miners joined the military, found employment at Bay Area shipyards, or moved to other mining communities in other states. The sudden silence took the locals by surprise, accustomed as they were to the constant 24-hour din of the stamp mills. After the war ended in 1945, the mines reopened and for a while tried to survive, but the extraction of gold became too costly to produce a profit. (Jim Johnson.)

CHINATOWN DEMOLISHED. A steady decline in population caused Chinatown to deteriorate over the years. Efforts to promote its temple to tourists failed, and Chinatown was razed in 1938. Prominent citizen Eddie Tinloy did much to preserve Grass Valley's Chinese heritage. His daughter Alice stands in the tall headdress on this July 4, 1935, float with Doll Yuen, Daisy Chun, Ruth and Amy Cheung, Helen Gon Chan, and Laura Lee Goudge. A local road was recently named for the Tinloys. (Alice Tinloy Yun.)

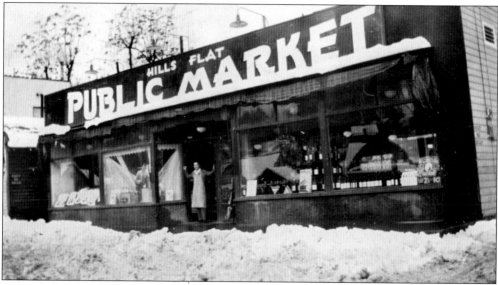

PIONEER FAMILIES. Arthur Fong Yun first came to Grass Valley in 1934. He took over a small butcher shop at East Main and Eureka Streets, enlarged it twice, and turned it into a flourishing market. Employee Henry Gee was photographed at its door c. 1930. Arthur and Faye's son Ed served in World War II. Grass Valley classmates Ed Yun and Alice Tinloy met again later while studying at U.C. Berkeley and married in 1947. (Ed Yun.)

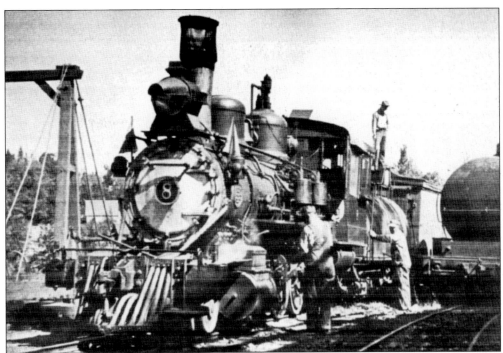

THE NARROW GAUGE RAILROAD. This track line survived winter storms, fires, and wrecks, but with closure of the gold mines—its major customers—and increasing automobile traffic, the railroad was abandoned in 1942 after 66 years of service. Jim Morley's photograph captures Engine No. 8 wearing a wartime blackout hood on her headlamp, as it prepares to take the last scheduled train to Colfax, "freighted with memories, down shining rails into history." (*Gold Cities* by Jim Morley and Doris Foley, 1965.)

THE SAGA OF THE MAN WHO BLAZED THE TRAIL FOR THE IRON HORSE ACROSS THE WIDE FRONTIER!

JOHN PAYNE
MARI BLANCHARD
DAN DURYEA

RAILS INTO LARAMIE

COLOR BY *Technicolor*

JOYCE MacKENZIE
BARTON MacLANE

STARDOM FOR ENGINE NO. 5. When the railroad closed, the pride of the railroad's roster of locomotives, a 26-ton Mogul built in 1874, was rebuilt, sold, and shipped to Hollywood's Frank Lloyd Productions. In 1942, it appeared in the opening scene of *The Spoilers*, starring John Wayne and Marlene Dietrich, and later in *Rails into Laramie*. After a 35-year career, Engine No. 5 is on a 75-year lease to the Nevada County Railroad Museum from Universal Studios. (Author's collection.)

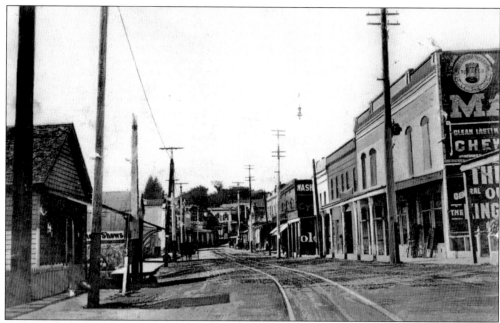

THE WATERFRONT. The stretch from 110 to 124 East Main Street, known as "the waterfront," was the site where watering holes stayed open all night and successful "madams" capitalized on Grass Valley's frontier spirit, in spite of the 1914 Red-Light Abatement Act, designed to end "commercial vice" in California. Historian Michel Janicot related how, in an effort to protect its soldiers' health, the U.S. Army was eventually called in to force the brothels to close in 1942. (LaVonne Mullin.)

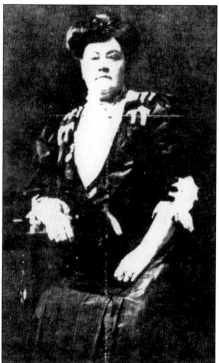

THE MINERS' FRIEND. Maybelle Foster ran a "boardinghouse" at 114 Stewart Street close to the police station, behind today's city hall. Born Melissa Beebe, Maybelle was described by Michel Janicot as "a squat brunette with a bulldog face and disposition to match." Famous for her charitable contributions, she was said to have "a heart like a hotel, there was room for everyone." (Michel Janicot.)

LOLA MONTEZ THEATER. The building at 116 West Main was home to the Lola Montez Theatre in the 1930s and 1940s and later to the Montgomery Ward Catalog Store. Bernice Glasson's husband, Jack Keegan, owned both the Montez and Del Oro Theaters. (LaVonne Mullin.)

DEL ORO THEATRE. Construction of the Del Oro at 167 Mill Street started in late 1941, but work on the project ceased during World War II when supplies became unavailable. The art deco–style theatre, designed by architect O. A. Deichmann, was completed in 1946. The older Strand Theater closed the same day the Del Oro opened. (Jim Johnson.)

GRASS VALLEY TURNS ART DECO. Movies helped spread interest for the new and alluring art deco style, which took over the town and altered its persona. Besides the Montez and Del Oro Theaters, the Masonic Temple at 128 South Auburn was built with the new stylized art deco lines in 1937. Along with the Bret Harte Inn, also in Grass Valley, the temple was one of the three tallest buildings in Western Nevada County. (Author's collection.)

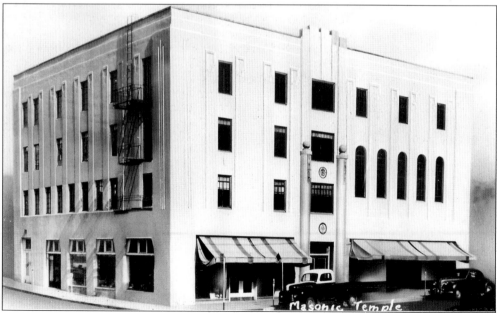

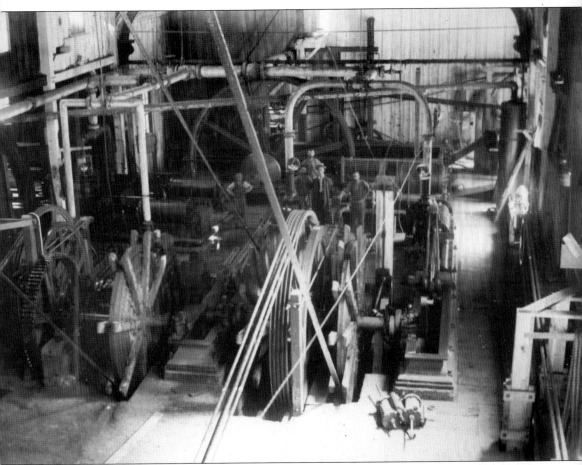

THE END OF AN ERA. After an estimated 5.8 million ounces of gold was extracted from the Empire Mine's 367 miles of tunnels since 1850, the pumps were pulled, the tunnels flooded, and thousands of tons of machinery and supply auctioned off in 1956. According to local Phil Oyung, the mills' salvaging crews found gold embedded in the gravels and in the old timbers of the stamp mills. They burned the huge old timbers to retrieve the gold. The liquidation clearly marked the end of a 100-year era when gold was the principal contributor to Grass Valley's economy. In 1975, the Empire property was purchased by the State of California for $1.25 million, and the mine and 750 acres were turned into a state historic park and mining museum. In 1970, local businessman Glenn Jones spearheaded the creation of the North Star Mining Museum in the mine's beautiful stone powerhouse in Boston Ravine by Wolf Creek. (Searls Library.)

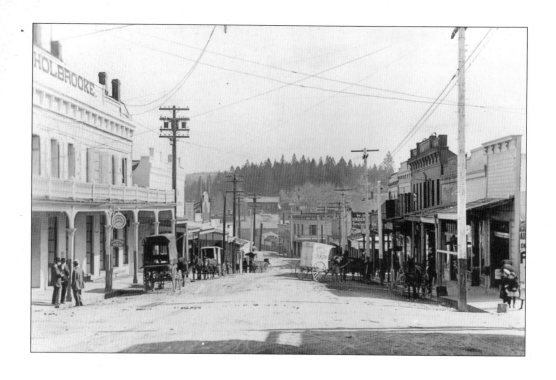

GRASS VALLEY OLD AND NEW. These images were taken from West Main Street looking toward Cemetery Hill in the 1890s and again in the 1940s. (Above Jim Johnson; below Comstock Bonanza Press.)

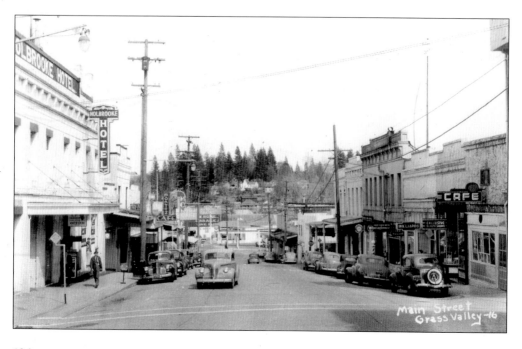

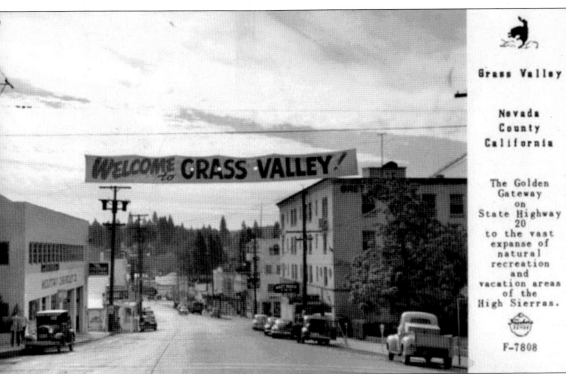

Grass Valley

Nevada
County
California

The Golden
Gateway
on
State Highway
20
to the vast
expanse of
natural
recreation
and
vacation areas
of the
High Sierras.

F-7808

THE GRASS VALLEY DOWNTOWN ASSOCIATION. Over the years, as the mines began to fade, the fortunes of the town began to fade as well. Then, in the early 1960s, the building of the Golden Center freeway reversed the trend and opened the town to new businesses and tourism. In 1981, the retail merchants formed the Grass Valley Downtown Association, and in 1986, they incorporated the National Trust for Historic Preservations model of the Main Street Program. Since that time, a productive partnership has flourished between the Grass Valley Downtown Association, the city of Grass Valley, and local merchants, all with a commitment to a vibrant historic downtown business district that embraces the incredible legacy of our past while implementing our vision for the future. It is our collective goal to provide both residents and visitors alike with an enjoyable experience that is defined by amazing stores, incredible eateries, and unique events, all in a warm and friendly atmosphere that has become the cornerstone of our historic town. (Jim Johnson.)

ACROSS AMERICA, PEOPLE ARE DISCOVERING
SOMETHING WONDERFUL. THEIR HERITAGE.

Arcadia Publishing is the leading local history publisher in the United States. With more than 3,000 titles in print and hundreds of new titles released every year, Arcadia has extensive specialized experience chronicling the history of communities and celebrating America's hidden stories, bringing to life the people, places, and events from the past. To discover the history of other communities across the nation, please visit:

www.arcadiapublishing.com

Customized search tools allow you to find regional history books about the town where you grew up, the cities where your friends and family live, the town where your parents met, or even that retirement spot you've been dreaming about.